Sketchits!

FACES & FASHION

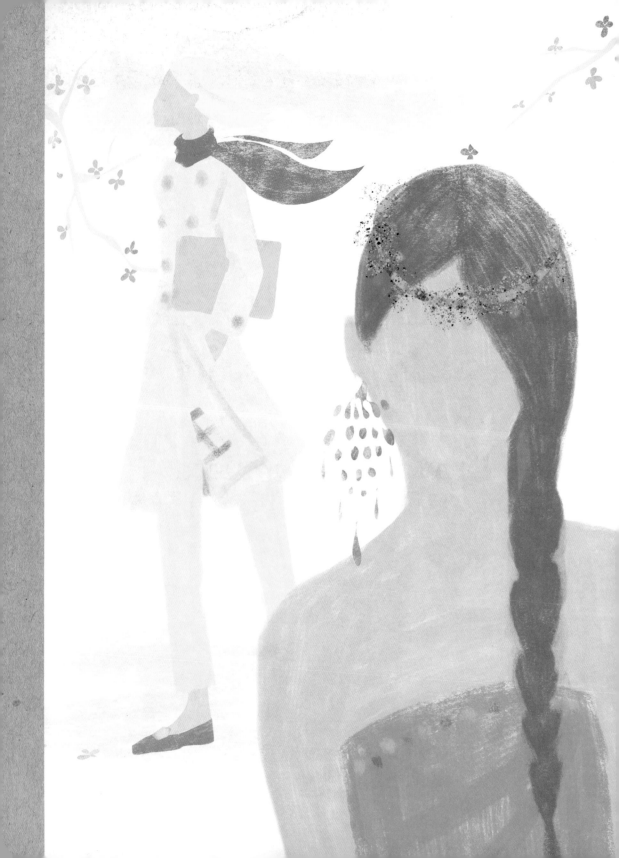

Sketchits!
FACES & FASHION

Draw and Complete
100+ COLOR TEMPLATES

Mixed Media Resources
New York

DRAWING WITH Christopher Hart

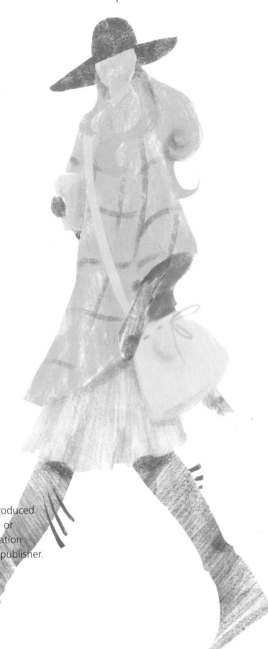

An imprint of Mixed Media Resources
104 West 27th Street
New York, NY 10001

Colorwork by VIRGINIA ROMO

Editorial Director
JOAN KRELLENSTEIN

Senior Editor
MICHELLE BREDESON

Managing Editor
LAURA COOKE

Art Director
IRENE LEDWITH

Editorial Assistant
JACOB SEIFERT

Production
J. ARTHUR MEDIA

Vice President
TRISHA MALCOLM

Publisher
CAROLINE KILMER

Creative Director
JOE VIOR

Production Manager
DAVID JOINNIDES

President
ART JOINNIDES

Chairman
JAY STEIN

I'd like to thank Virginia Romo for contributing her talents to this book.
—Christopher Hart

ISBN: 978-1-942021-49-0

Printed in China.

1 3 5 7 9 10 8 6 4 2

christopherhartbooks.com

Contents

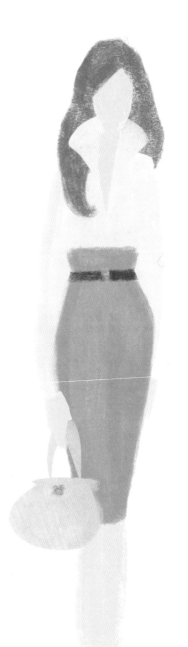

Introduction

IF YOU'RE LIKE ME, YOU LOVE TO DRAW.

I've illustrated many art instruction books that have
helped aspiring artists learn to draw various genres
and subjects. Recently, an idea struck me for a new
and exciting approach to drawing. I was sitting in a
café in Paris. It was a beautiful fall day. Or maybe it
was Brooklyn and kind of drizzly. The point is that it
occurred to me that creative people love to draw, not
just color. (Now that I think about it, it was Brooklyn.)
But they also like seeing their work in color. So I
thought, what if instead of coloring within existing
lines, like in a coloring book, you drew your lines
over existing colors, resulting in a complete,
full-color drawing? That would instantly bring
your drawings to life!

To give the book style, I chose fashion for its theme.
This book will give you a variety of color templates,
so you can customize your drawings. You can draw
the faces and figures any way you like. And you don't
have to stay exactly within the outlines of the color
templates. They're only suggestions. I'll give you some
tips on drawing facial features, creases and folds, and
patterns. And throughout the book, I've included
examples of how I might complete the drawings, to
get you inspired.

It's an exciting new way to draw, at home, in Paris,
or even Brooklyn.

—Christopher Hart

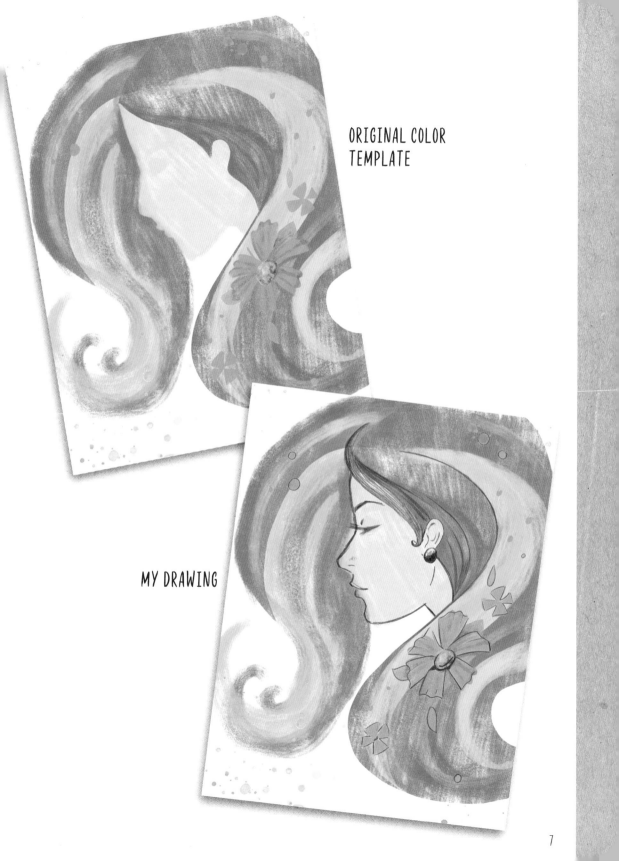

ORIGINAL COLOR
TEMPLATE

MY DRAWING

7

Sample Sketchits

You're a creative individual. Your way of drawing will express itself differently from anyone else's. To demonstrate, I asked several artists to draw over two different color templates. Each came up with his or her individual take on the subject matter.

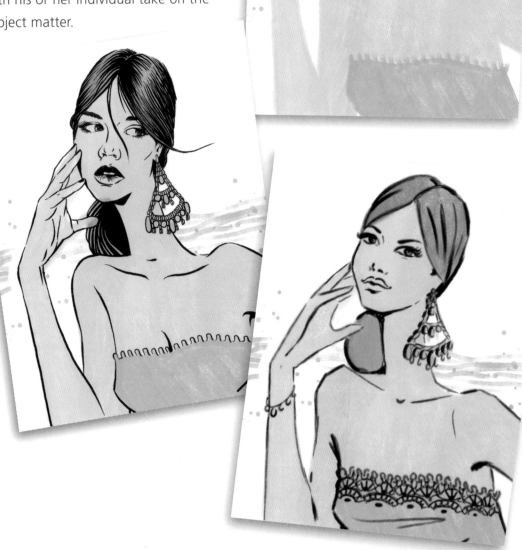

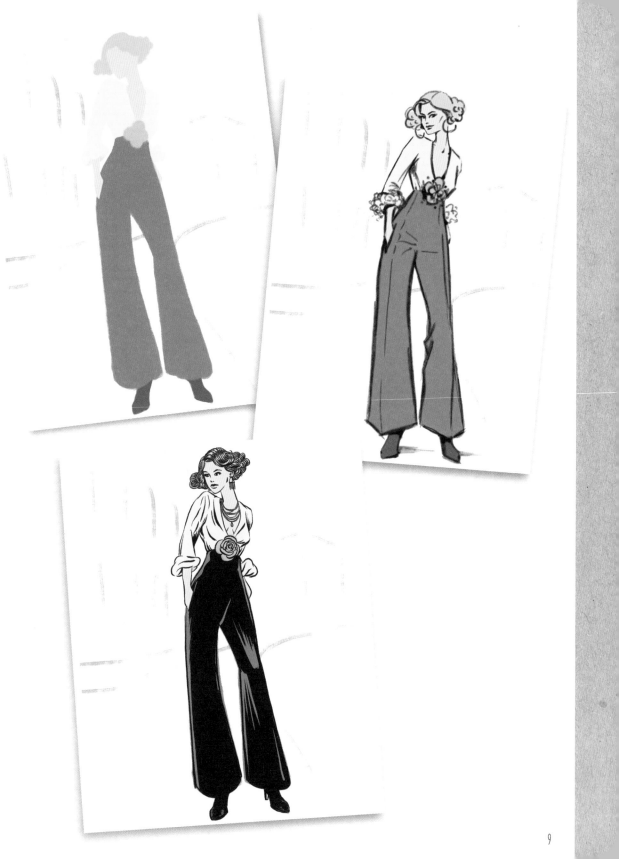

Sketchits!
FACES

Starting a drawing with a blank face can be intimidating. Before we jump into it, I'll share some hints and tips for drawing the features—eyes, nose, and lips—and adding details to the hair.

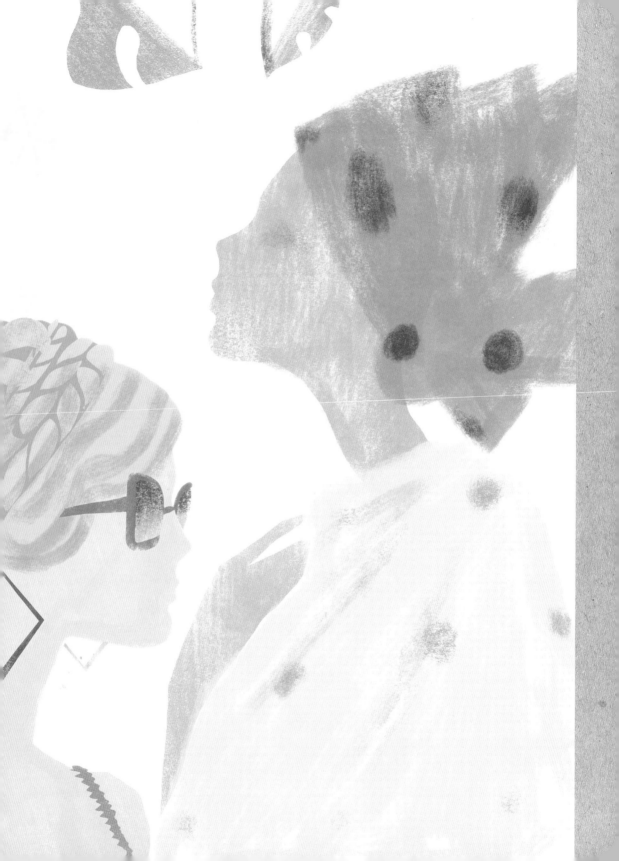

Drawing Eyes

The eyes are probably the most important features of the face, because they're so expressive. You can make them as glamorous or as casual as you like, depending on how much emphasis you place on the eyelashes. Keep in mind that the shape of the eye from the front is completely different from the profile.

Basic Eye

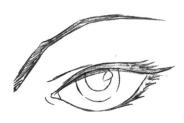

Front View
The female eye is almond-shaped with thin, arching eyebrows. The eyelashes brush softly to one side.

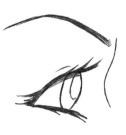

Side View
In profile, the eyelashes extend significantly forward and backward. The eyebrow arches from high to low.

Sample Eye Shapes

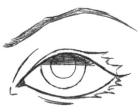

Almond Eye
The top eyelid has a subtle curve that is emphasized by the sweep of the eyelashes.

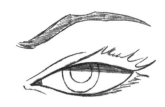

Slender Eye
The top eyelid hides more of the pupil for a sexy look.

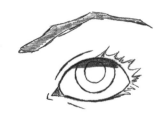

Round Eye
This is a cute, pert look. Feather the eyelashes around the eye.

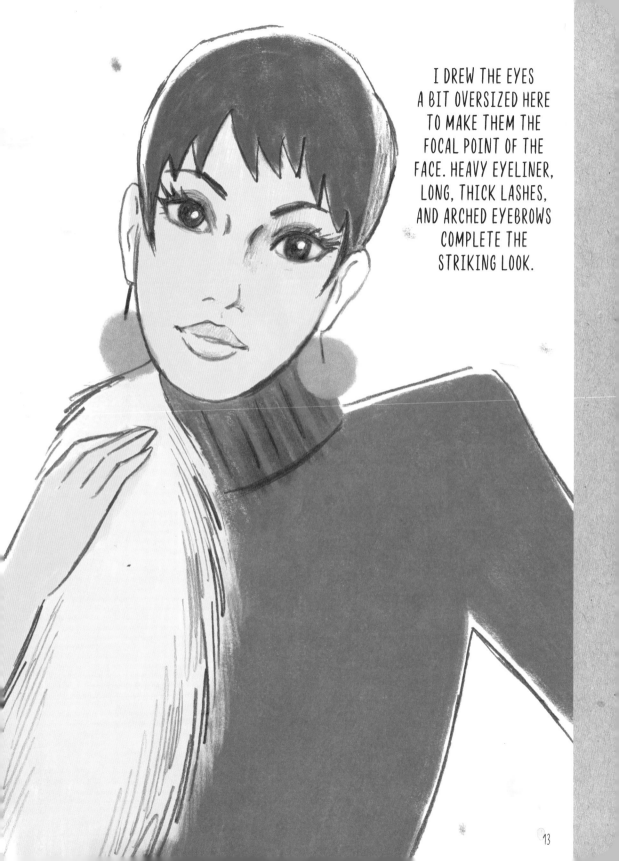

I DREW THE EYES
A BIT OVERSIZED HERE
TO MAKE THEM THE
FOCAL POINT OF THE
FACE. HEAVY EYELINER,
LONG, THICK LASHES,
AND ARCHED EYEBROWS
COMPLETE THE
STRIKING LOOK.

Noses and Lips

I like to draw a subtle curve from the bridge of the nose to the eyebrow. The tip of the nose aligns with the cupid's bow of the lip (the depression in the upper lip). When you draw the female nose, keep in mind that the fewer the details, the more feminine it looks.

Front View
Melding the top and bottom lips is an attractive look.

Side View
The lips are always shorter in the side view, and the nose angles up.

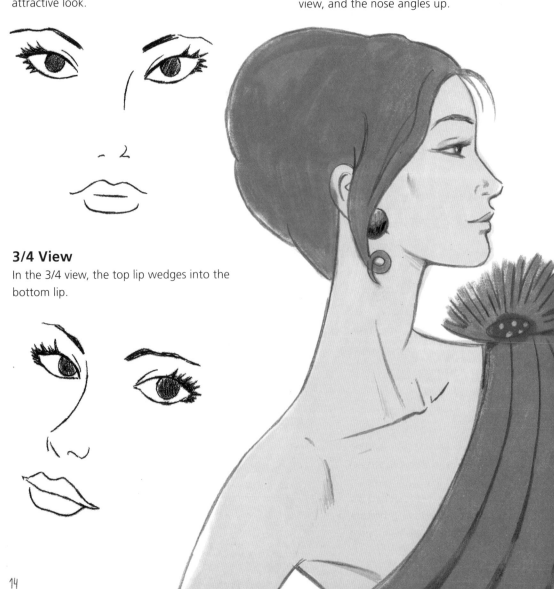

3/4 View
In the 3/4 view, the top lip wedges into the bottom lip.

Styling Hair

Hairstyles are a big part of the overall look of a model. The Sketchits color templates have the hair blocked in, but you'll still have plenty of opportunities to add details, such as strands that create the flow of the hair, as well as accessories.

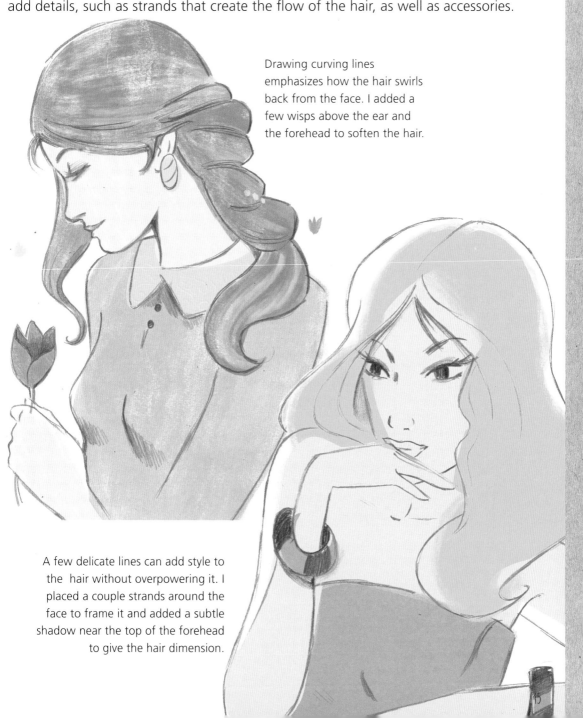

Drawing curving lines emphasizes how the hair swirls back from the face. I added a few wisps above the ear and the forehead to soften the hair.

A few delicate lines can add style to the hair without overpowering it. I placed a couple strands around the face to frame it and added a subtle shadow near the top of the forehead to give the hair dimension.

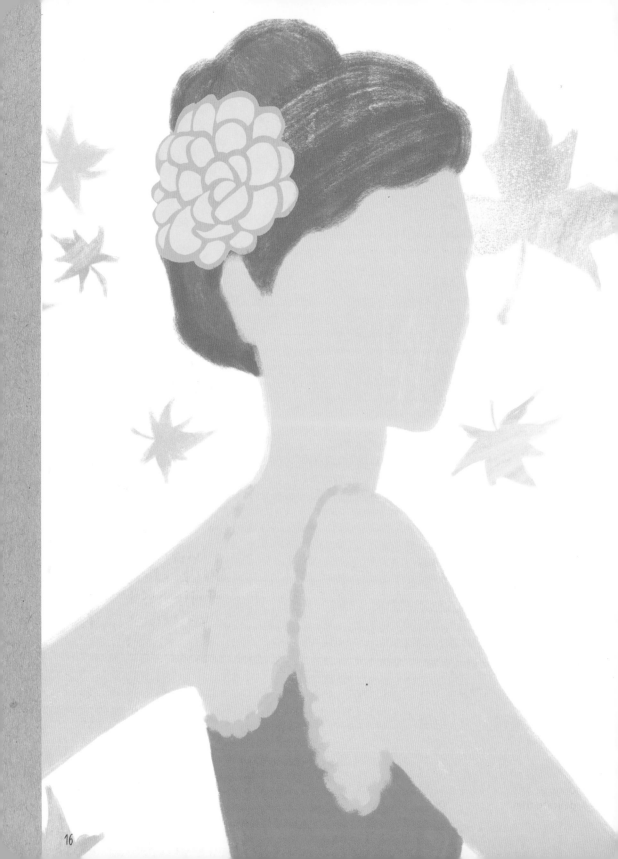

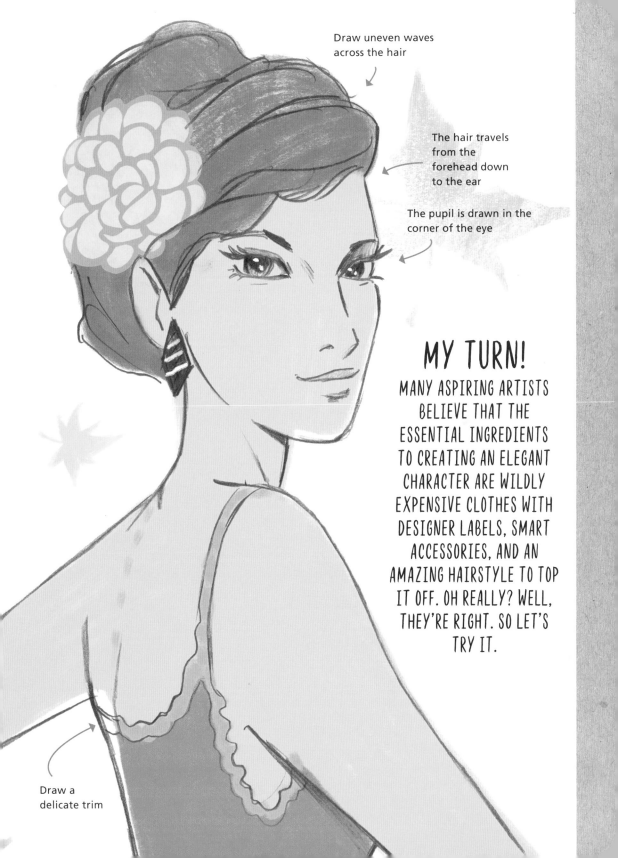

Draw uneven waves across the hair

The hair travels from the forehead down to the ear

The pupil is drawn in the corner of the eye

MY TURN!

MANY ASPIRING ARTISTS BELIEVE THAT THE ESSENTIAL INGREDIENTS TO CREATING AN ELEGANT CHARACTER ARE WILDLY EXPENSIVE CLOTHES WITH DESIGNER LABELS, SMART ACCESSORIES, AND AN AMAZING HAIRSTYLE TO TOP IT OFF. OH REALLY? WELL, THEY'RE RIGHT. SO LET'S TRY IT.

Draw a delicate trim

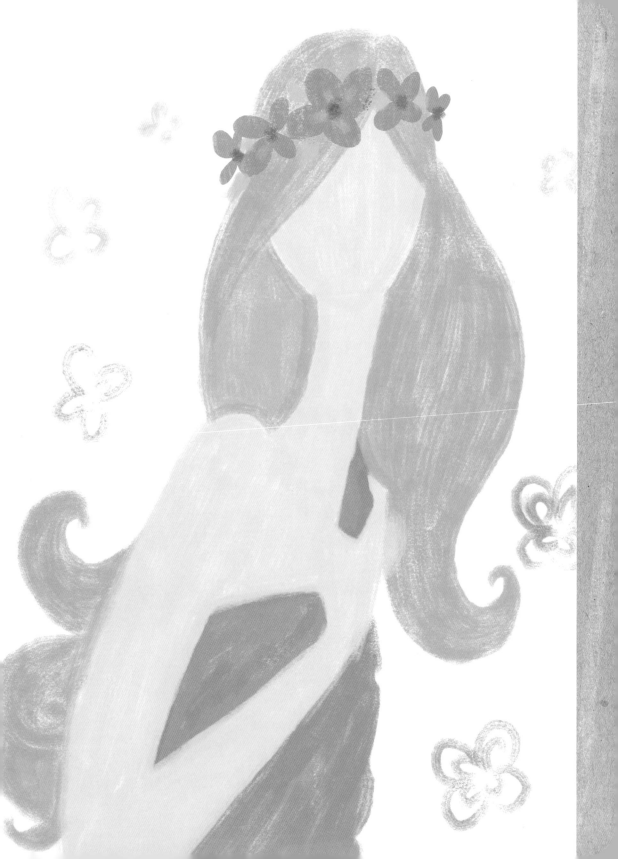

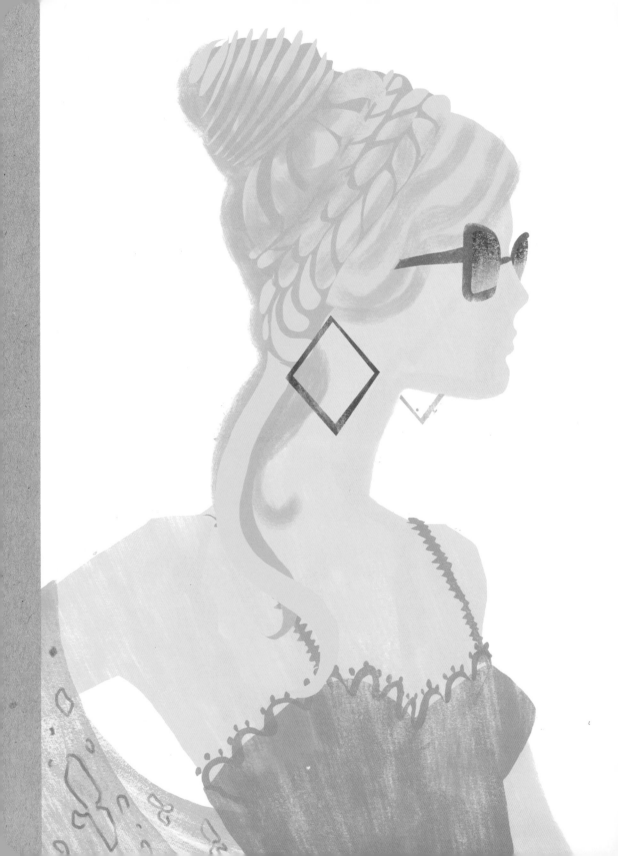

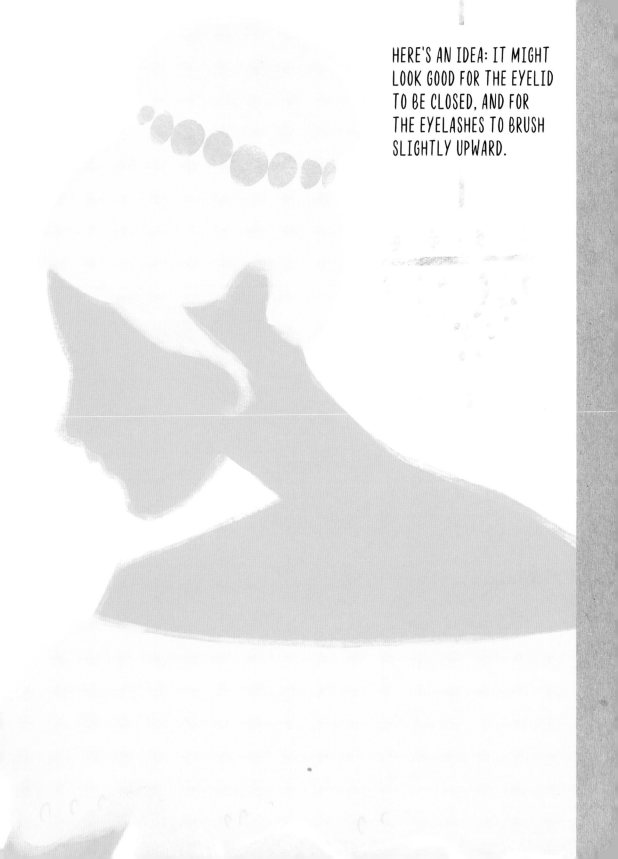

HERE'S AN IDEA: IT MIGHT LOOK GOOD FOR THE EYELID TO BE CLOSED, AND FOR THE EYELASHES TO BRUSH SLIGHTLY UPWARD.

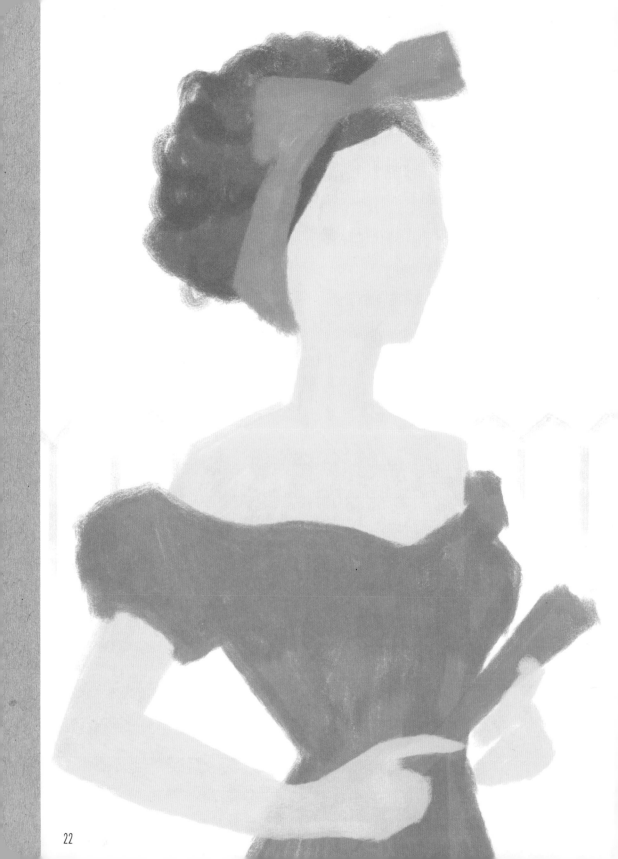

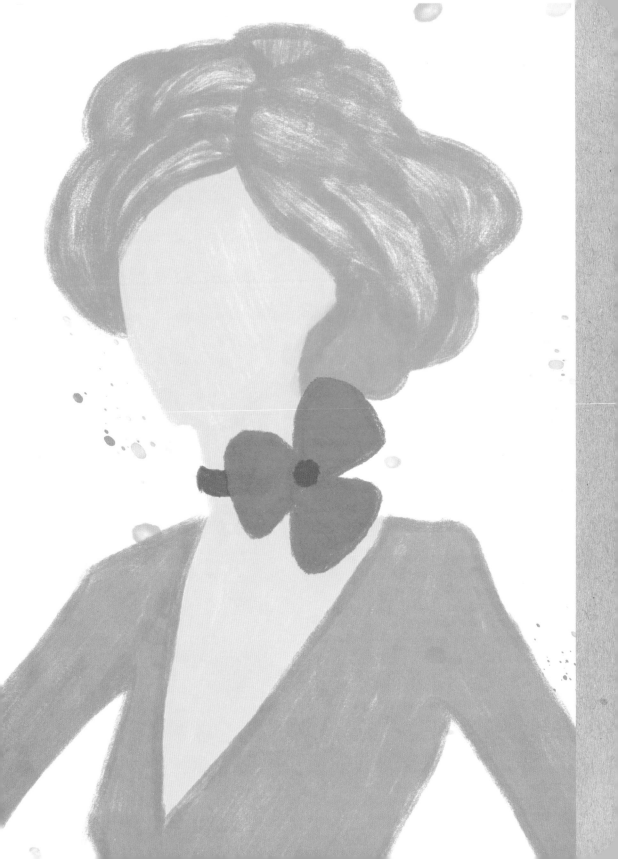

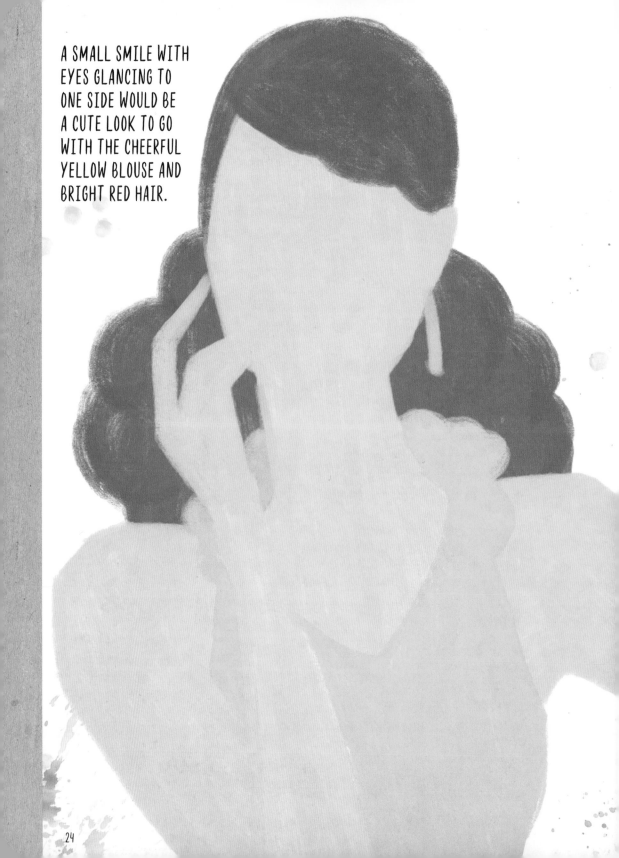

A SMALL SMILE WITH
EYES GLANCING TO
ONE SIDE WOULD BE
A CUTE LOOK TO GO
WITH THE CHEERFUL
YELLOW BLOUSE AND
BRIGHT RED HAIR.

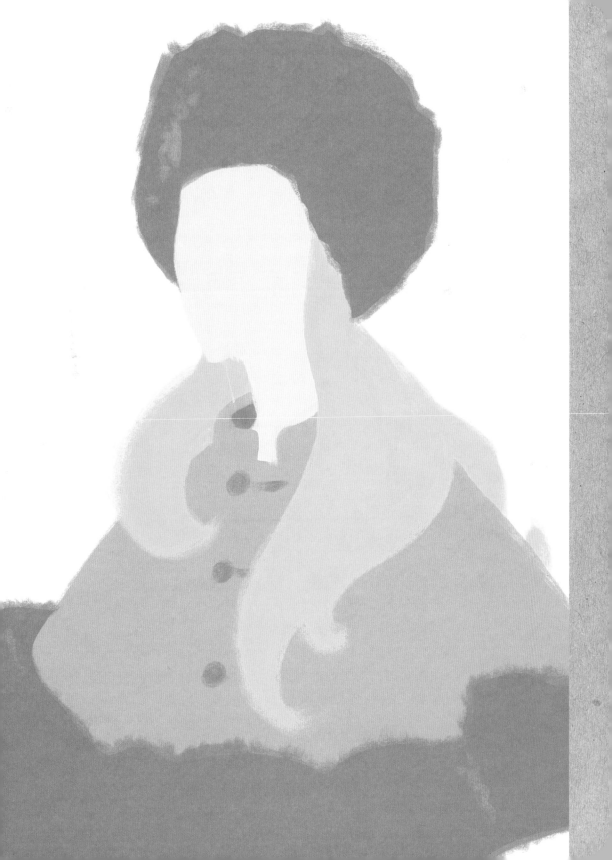

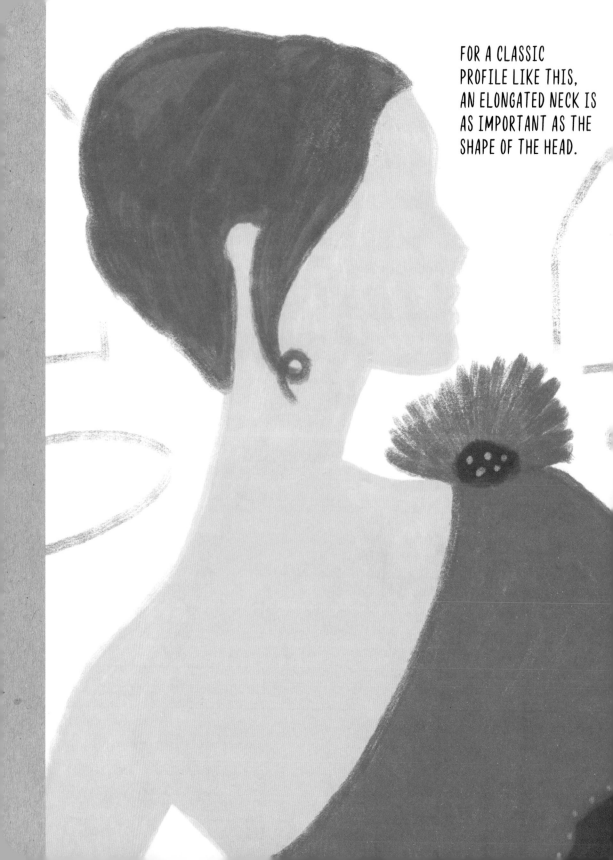

FOR A CLASSIC
PROFILE LIKE THIS,
AN ELONGATED NECK IS
AS IMPORTANT AS THE
SHAPE OF THE HEAD.

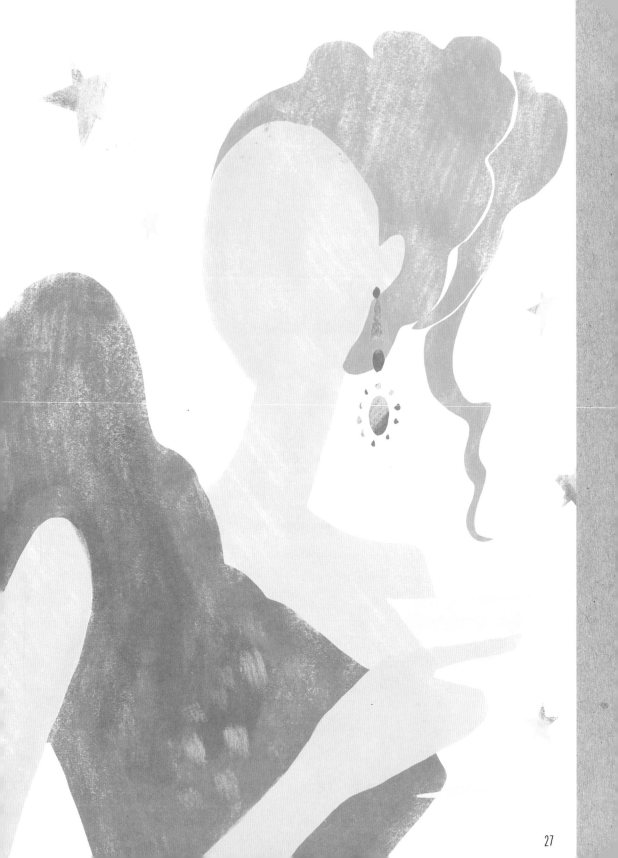

SHE'S FACING FORWARD,
BUT THAT DOESN'T MEAN
THAT HER EYES HAVE
TO. YOU CAN DRAW HER
GLANCING TO THE LEFT
OR TO THE RIGHT.

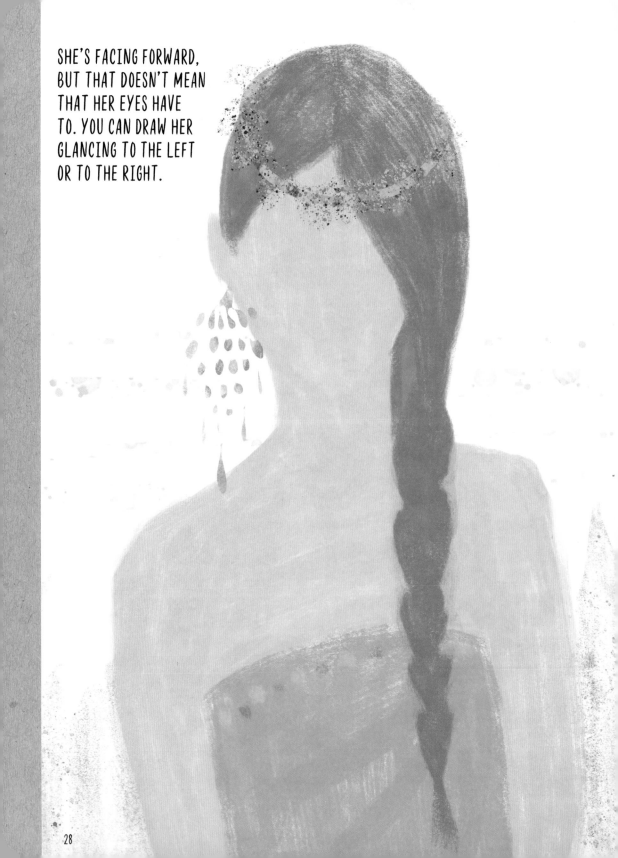

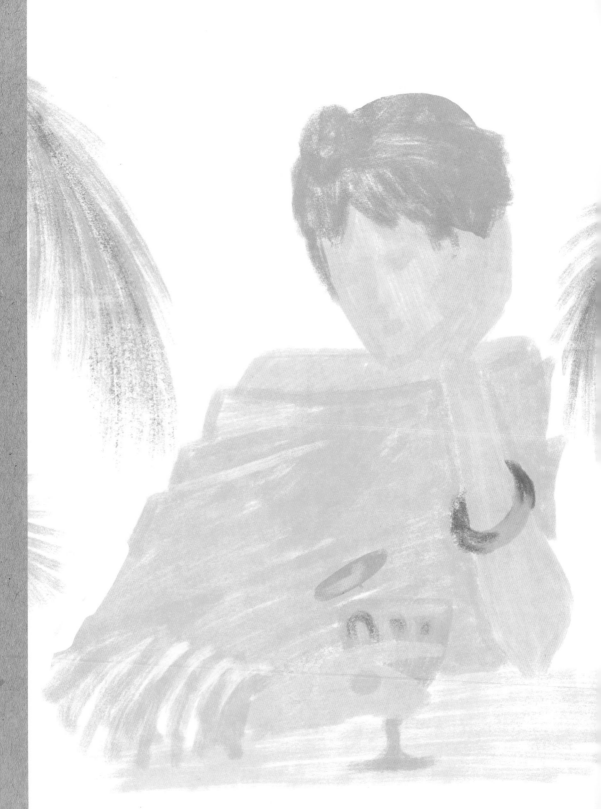

MY TURN!

SWEATERS TEND TO BUNCH UP. TO GIVE THEM A PLEASING LOOK, ADD SWEEPING LINES ACROSS THE TORSO. TO CREATE THAT WISTFUL SMILE, DRAW A GLANCE TO THE SIDE, COUPLED WITH SLIGHTLY WORRIED EYEBROWS.

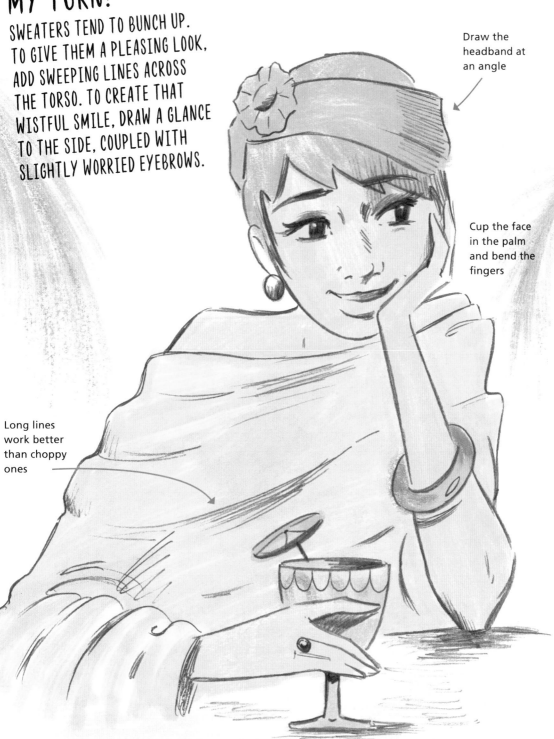

Draw the headband at an angle

Cup the face in the palm and bend the fingers

Long lines work better than choppy ones

TRY A DELICATE
APPROACH FOR THIS
REFINED CHARACTER.
KEEP THE LINES THIN
AND MINIMAL.

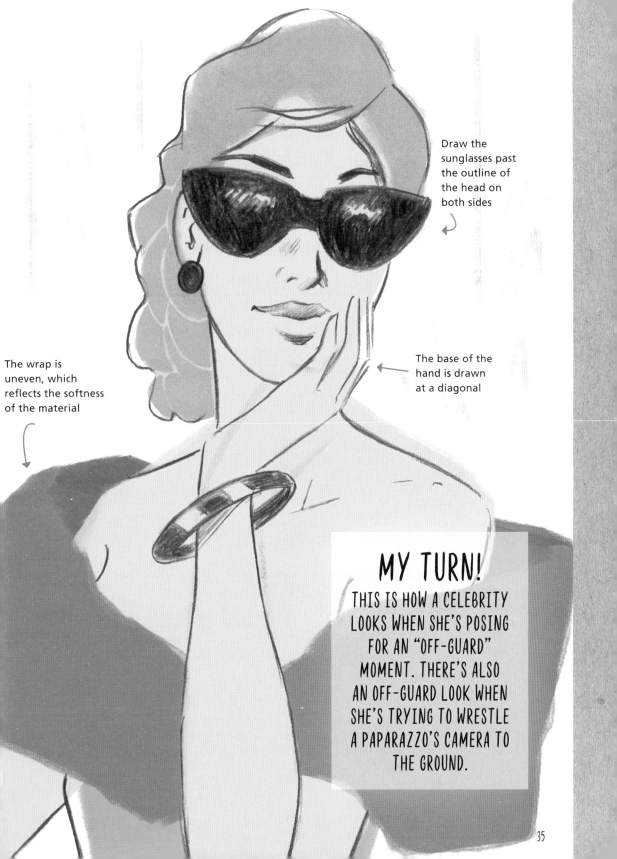

Draw the sunglasses past the outline of the head on both sides

The wrap is uneven, which reflects the softness of the material

The base of the hand is drawn at a diagonal

MY TURN!

THIS IS HOW A CELEBRITY LOOKS WHEN SHE'S POSING FOR AN "OFF-GUARD" MOMENT. THERE'S ALSO AN OFF-GUARD LOOK WHEN SHE'S TRYING TO WRESTLE A PAPARAZZO'S CAMERA TO THE GROUND.

IF YOU DRAW A BIG SMILE
WITH EYES CLOSED, IT
WILL LOOK LIKE SHE'S
HAVING FUN. IT'S A
GREAT EXPRESSION TO
USE WHEN DRAWING
FASHION MODELS.

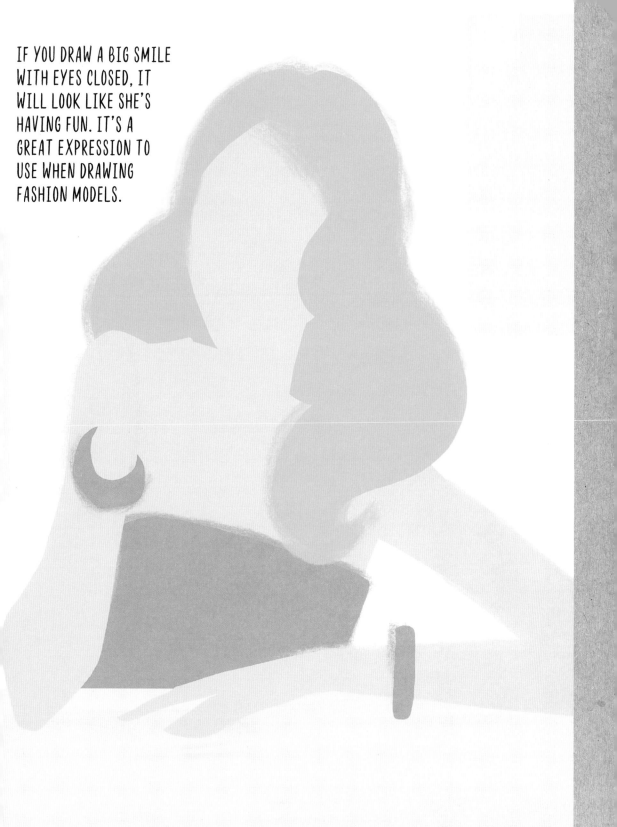

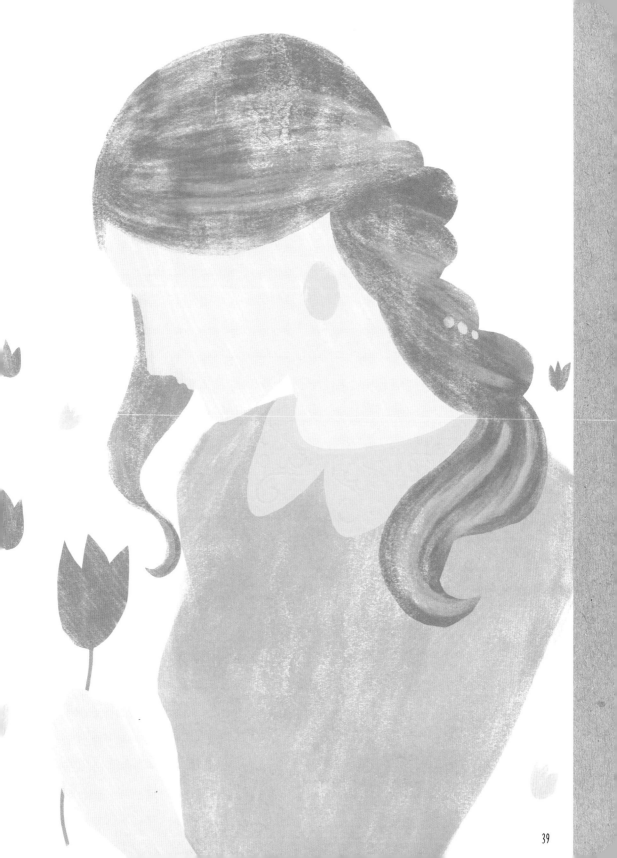

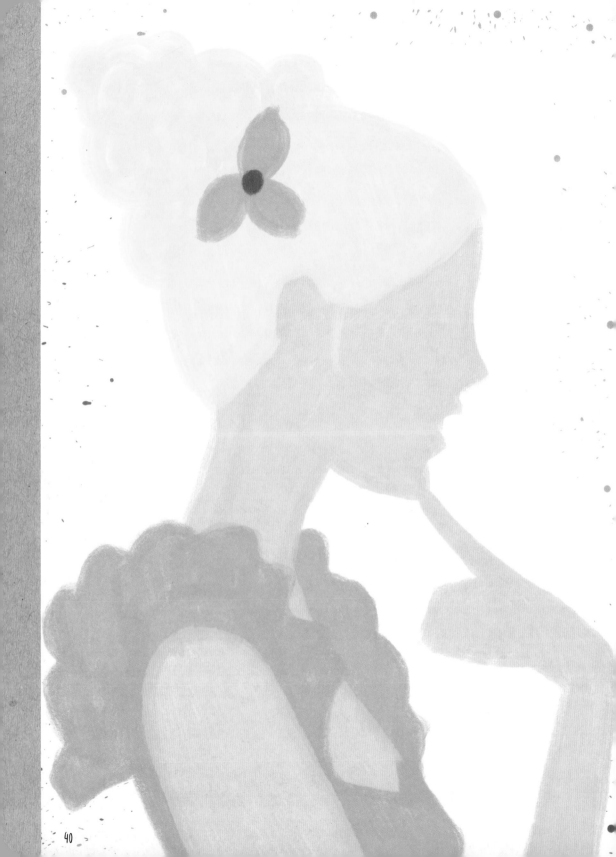

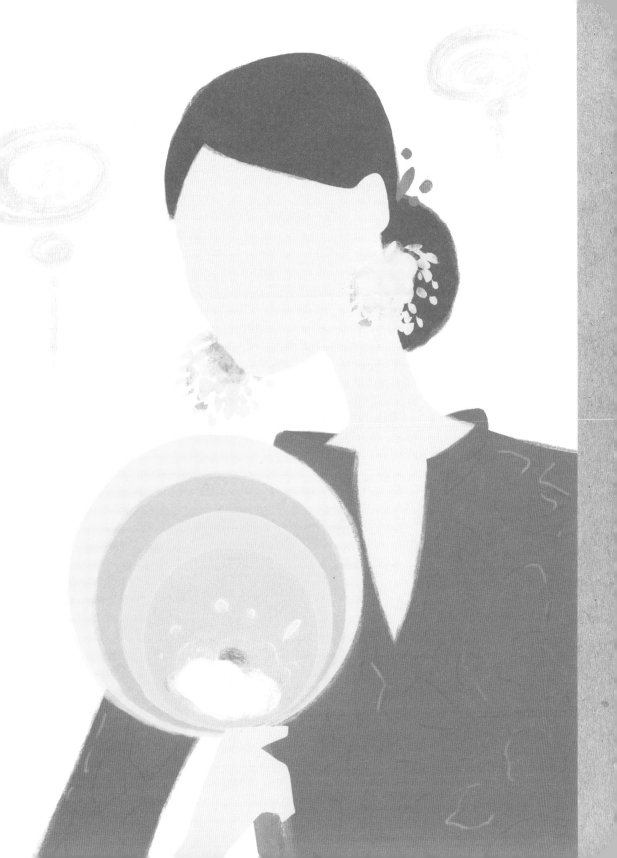

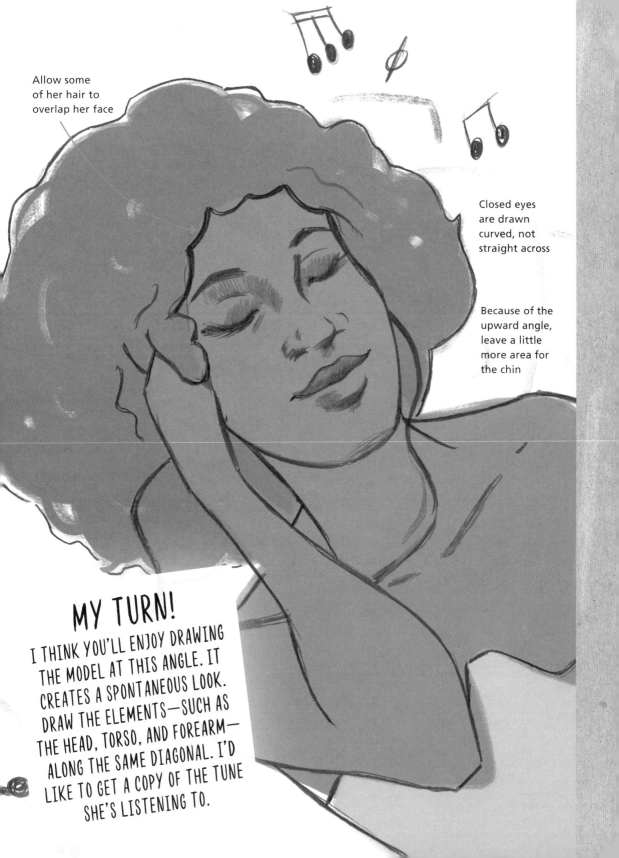

Allow some of her hair to overlap her face

Closed eyes are drawn curved, not straight across

Because of the upward angle, leave a little more area for the chin

MY TURN!
I THINK YOU'LL ENJOY DRAWING THE MODEL AT THIS ANGLE. IT CREATES A SPONTANEOUS LOOK. DRAW THE ELEMENTS—SUCH AS THE HEAD, TORSO, AND FOREARM— ALONG THE SAME DIAGONAL. I'D LIKE TO GET A COPY OF THE TUNE SHE'S LISTENING TO.

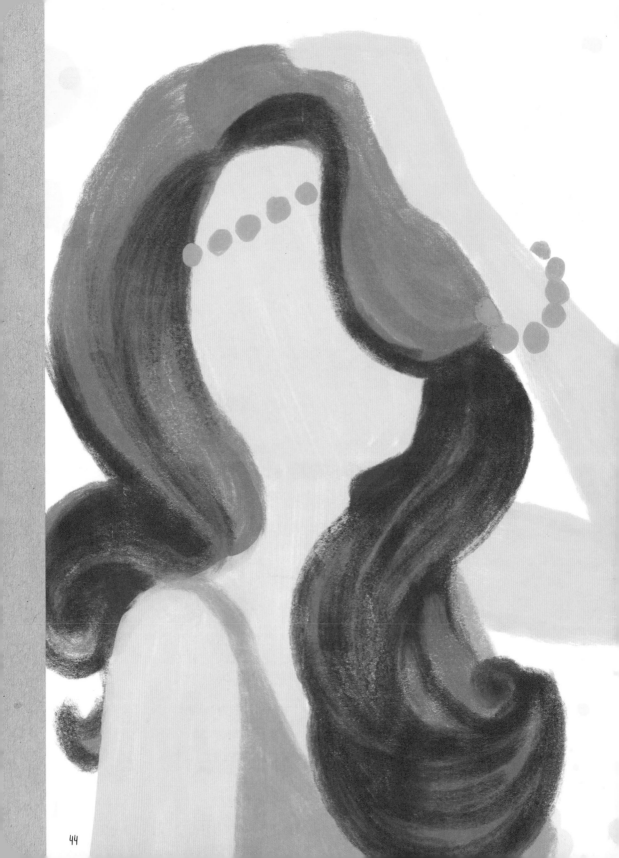

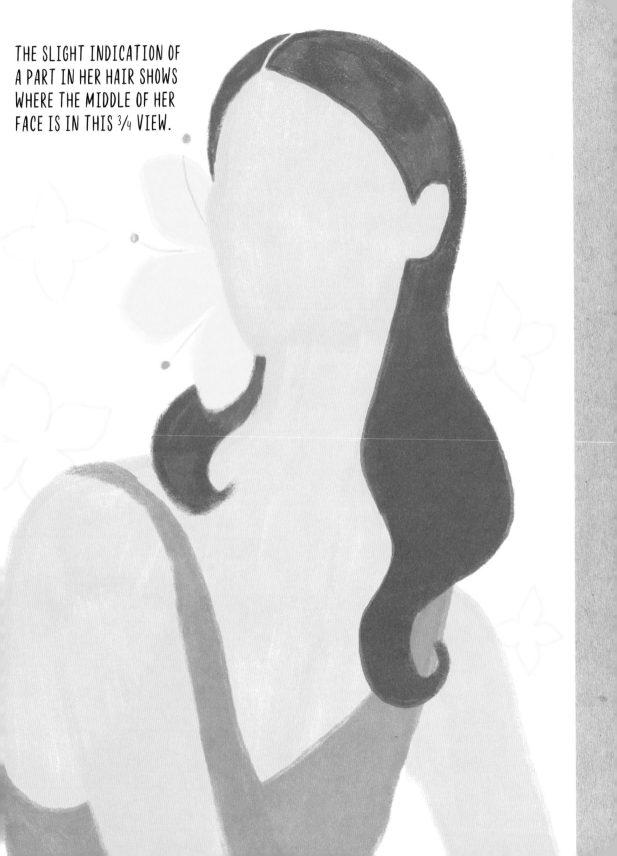

THE SLIGHT INDICATION OF A PART IN HER HAIR SHOWS WHERE THE MIDDLE OF HER FACE IS IN THIS ¾ VIEW.

YOU MIGHT ALSO SHOW A HINT
OF HER HAIR, JUST BELOW THE
SWIM CAP. I TRIED IT, AND
ADDED A SMALL WATER DROPLET
HANGING FROM HER CHIN.
GOGGLES?

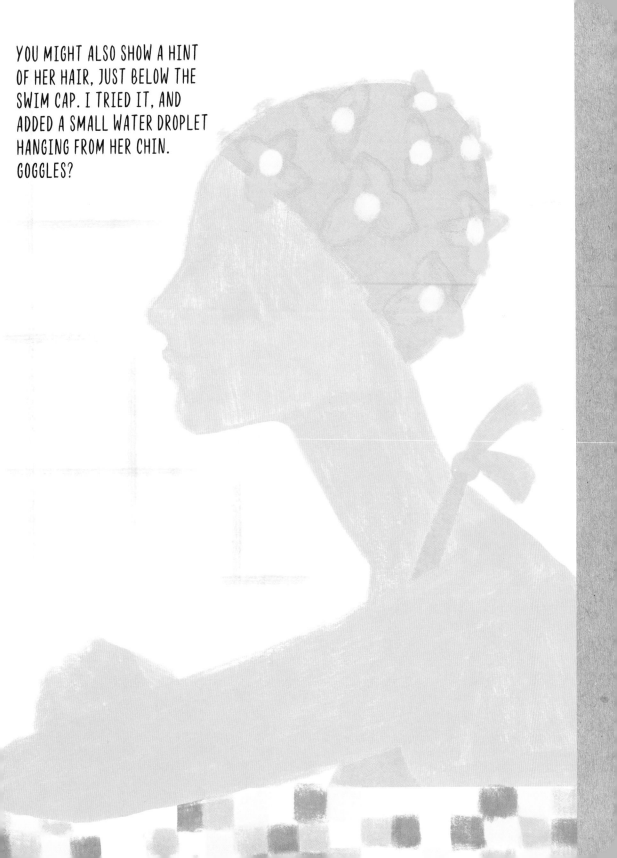

Sketchits!
FASHION

This section features full-length figures in eye-catching outfits. There are many elements you can draw, from clothes to wraps to purses and accessories. You can also draw fabric patterns, folds and creases, and more.

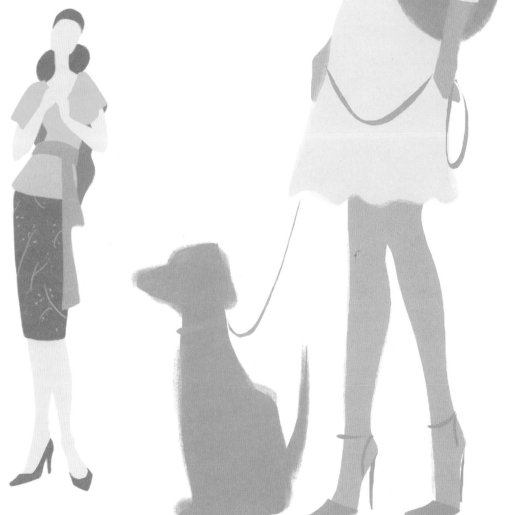

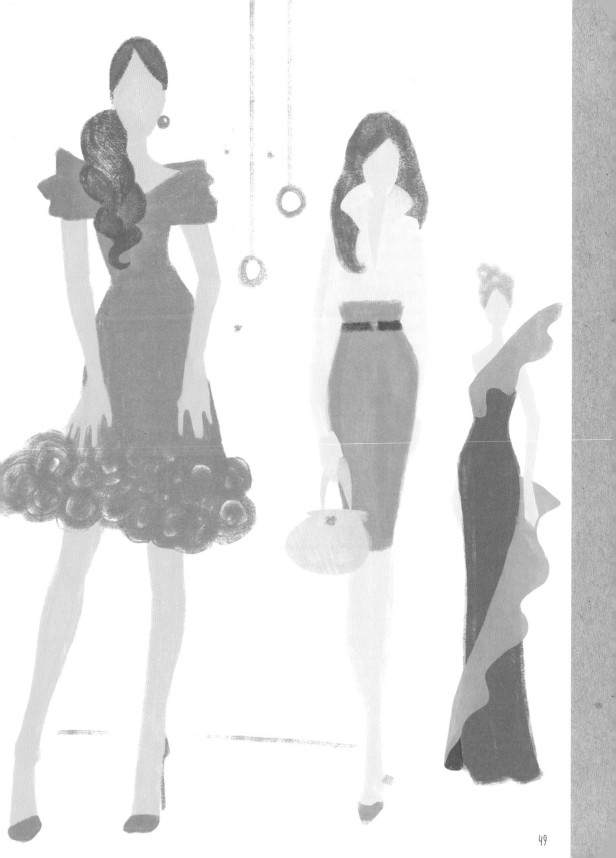

Drawing Creases and Folds

Adding creases and folds to clothing helps to indicate the figure and prevents the drawing from appearing flat. Drawing folds makes clothing look natural and gives it texture. Although folds look random to the average reader, artists draw them in certain patterns.

Creases in Sleeves

Creases in sleeves generally radiate outward from the point of compression.

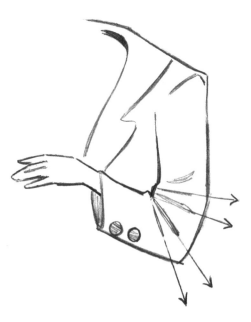

Creases in Pants and Boots

Folds in pants and boots generally occur at the ankles, where the material gathers, and where there's a lot of stress—such as at the crotch and the knees.

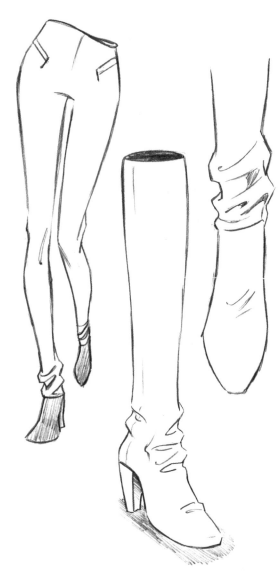

Folds in Tops

Some folds swing back and forth diagonally. Hanging drapery does this, but so do folds that run across the body. The folds are more pronounced when the fabric is twisted, tight, or compressed.

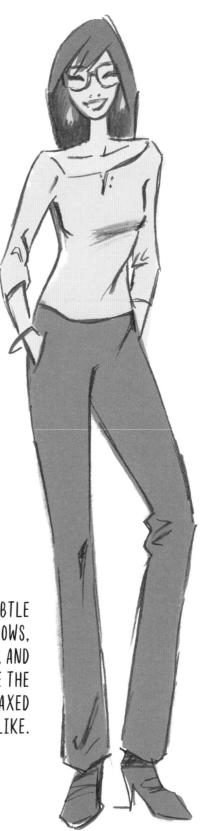

NOTICE HOW THE SUBTLE CREASES AT THE ELBOWS, KNEES, ANKLES, AND ELSEWHERE MAKE THE DRAWING LOOK RELAXED AND LIFELIKE.

Adding Patterns

Not all clothing has, or should have, patterns, but adding patterns to fashion figures is a fun way to personalize them. Feel free to use the examples shown here or make up your own! Here are some hints for how the patterns should be drawn on the figure to follow the shape and flow of the fabric.

Sample Fabric Patterns

Plaid

The "straight" lines of plaids are actually drawn with subtle curves.

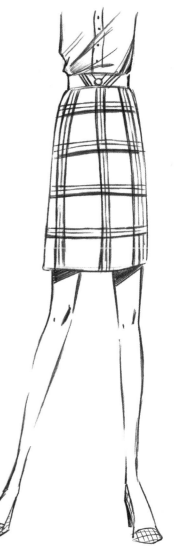

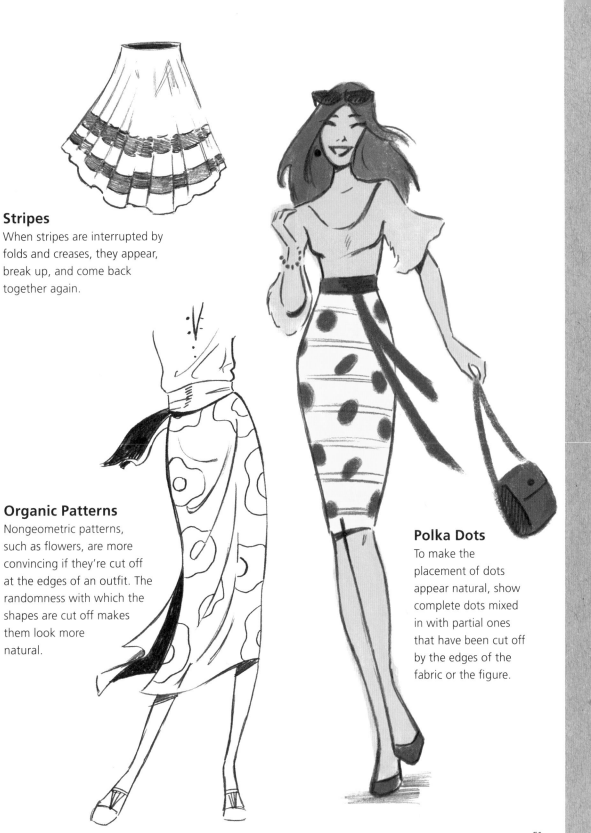

Stripes

When stripes are interrupted by folds and creases, they appear, break up, and come back together again.

Organic Patterns

Nongeometric patterns, such as flowers, are more convincing if they're cut off at the edges of an outfit. The randomness with which the shapes are cut off makes them look more natural.

Polka Dots

To make the placement of dots appear natural, show complete dots mixed in with partial ones that have been cut off by the edges of the fabric or the figure.

Accessorize!

Nothing completes an outfit like the right accessory! The Sketchits color templates have suggestions of shoes, and some include handbags, but you have plenty of room to add, customize, change, and embellish them. Here are some styles that will add pizzazz to the fashions.

Shoe Styles

Thong

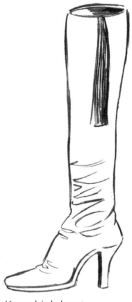

Knee-high boot

Flat

Platform mule

Wedge-heel boot

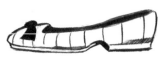

Ballet flat

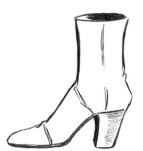

Chunky heel

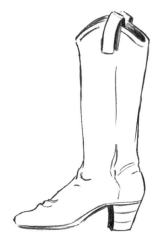

Cowboy boot

Short boot with fringe

Handbags

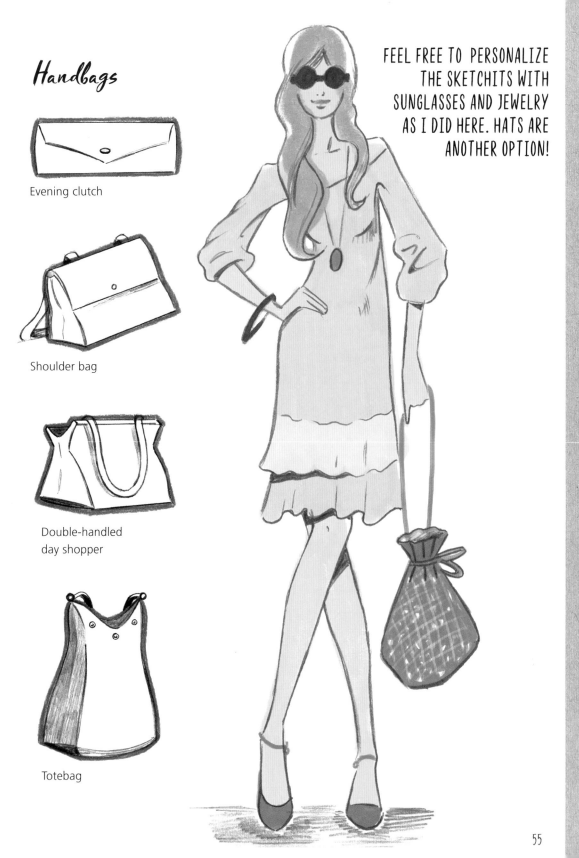

Evening clutch

Shoulder bag

Double-handled
day shopper

Totebag

FEEL FREE TO PERSONALIZE
THE SKETCHITS WITH
SUNGLASSES AND JEWELRY
AS I DID HERE. HATS ARE
ANOTHER OPTION!

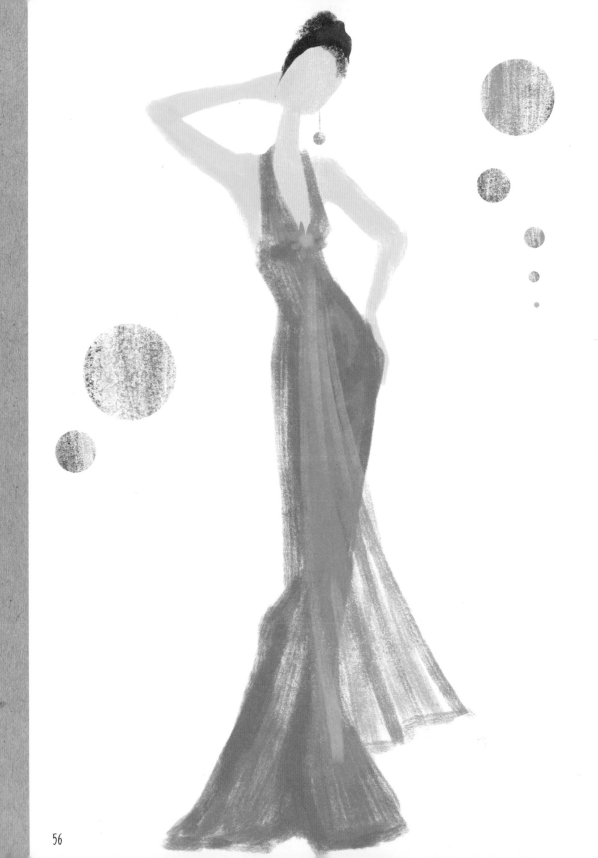

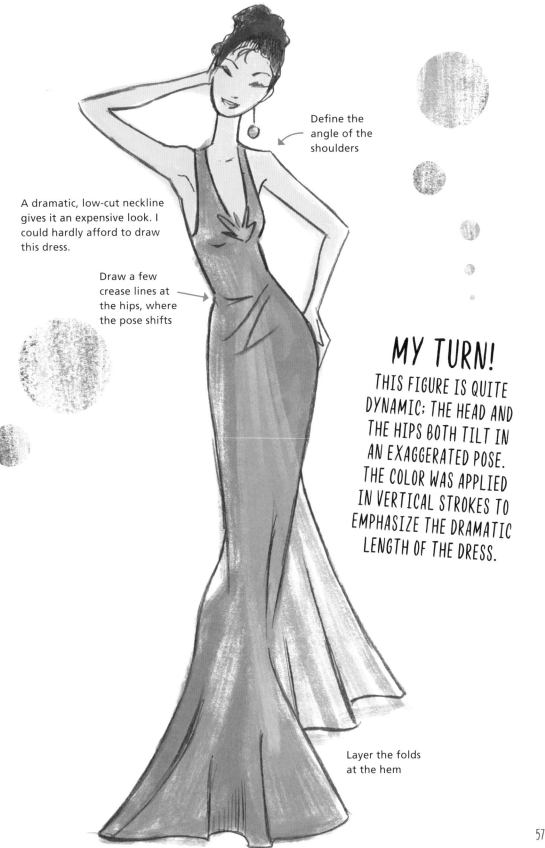

Define the
angle of the
shoulders

A dramatic, low-cut neckline
gives it an expensive look. I
could hardly afford to draw
this dress.

Draw a few
crease lines at
the hips, where
the pose shifts

MY TURN!

THIS FIGURE IS QUITE
DYNAMIC; THE HEAD AND
THE HIPS BOTH TILT IN
AN EXAGGERATED POSE.
THE COLOR WAS APPLIED
IN VERTICAL STROKES TO
EMPHASIZE THE DRAMATIC
LENGTH OF THE DRESS.

Layer the folds
at the hem

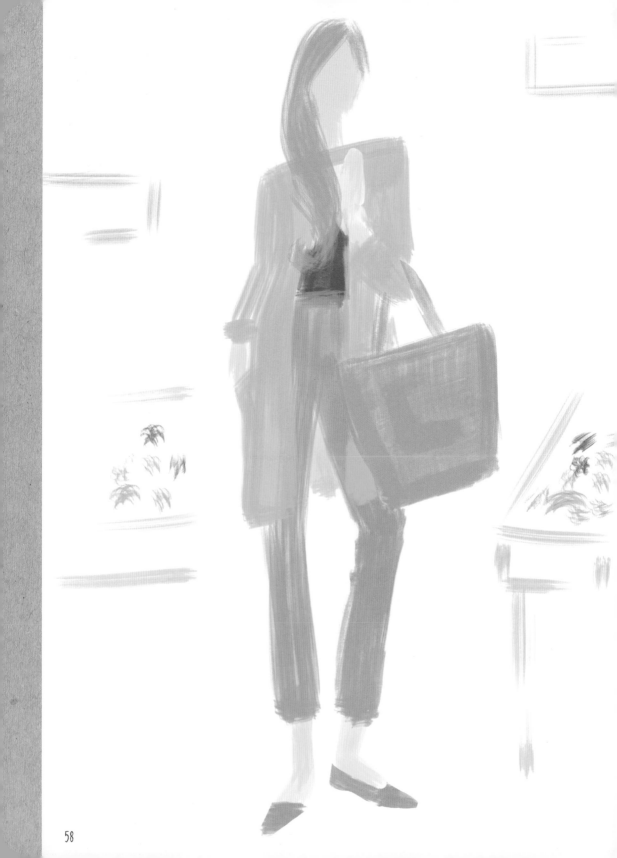

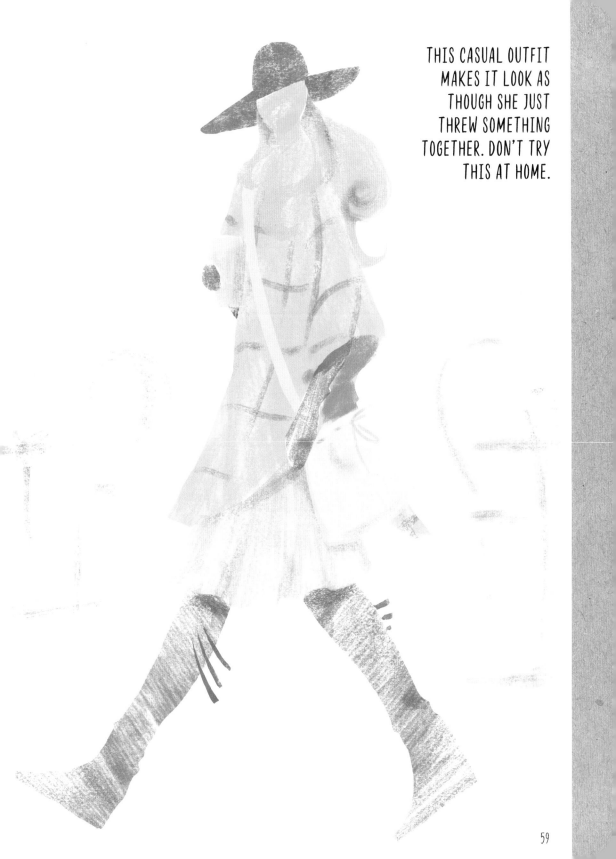

THIS CASUAL OUTFIT
MAKES IT LOOK AS
THOUGH SHE JUST
THREW SOMETHING
TOGETHER. DON'T TRY
THIS AT HOME.

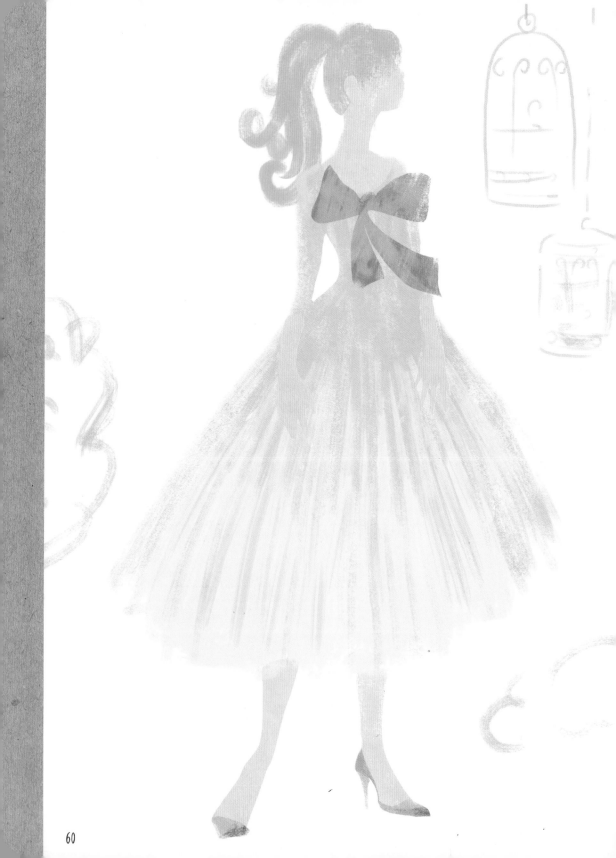

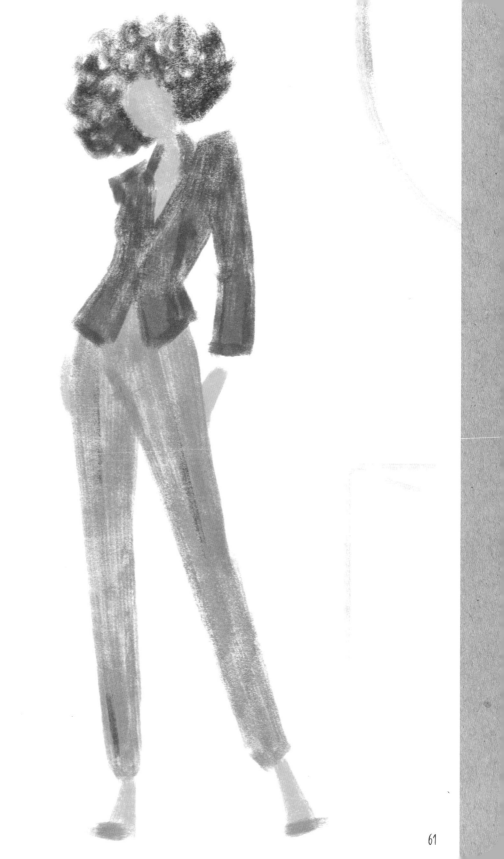

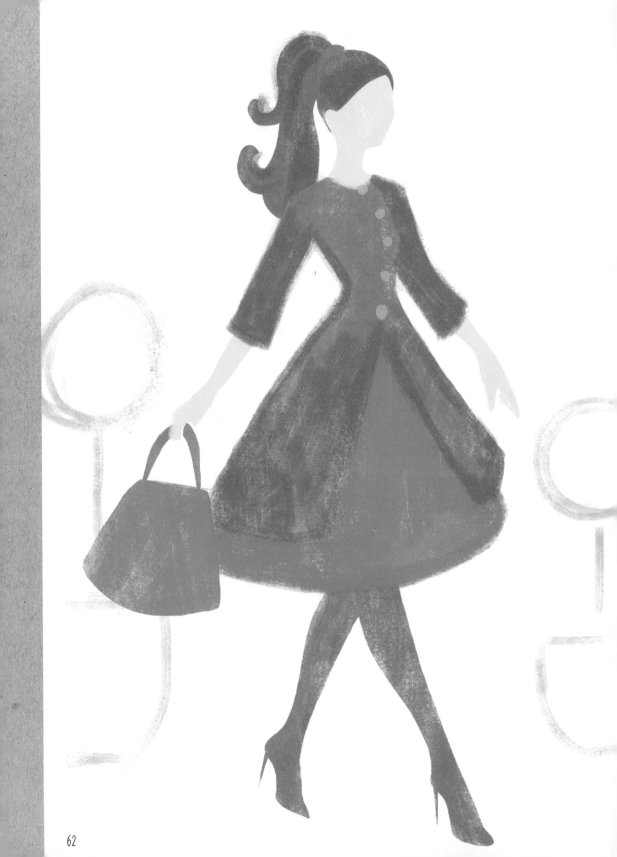

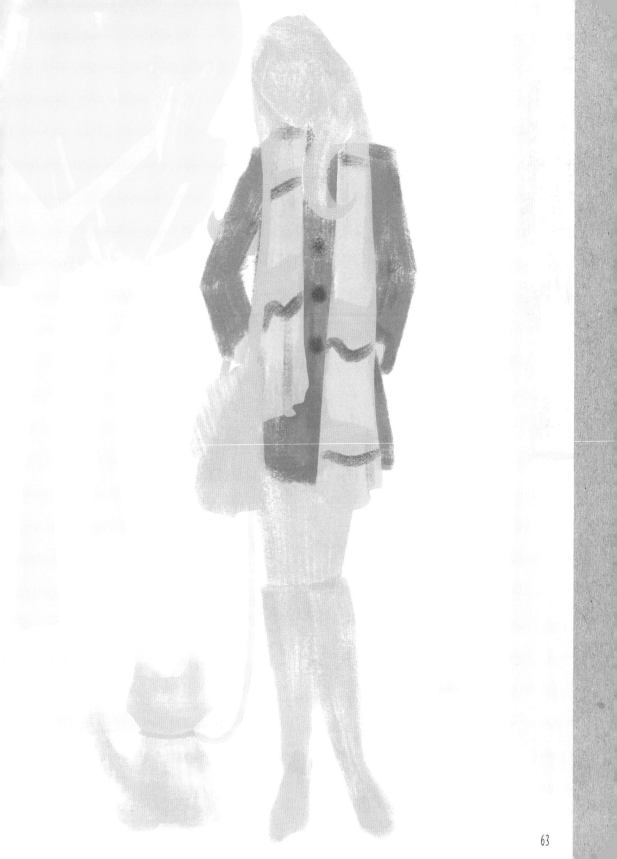

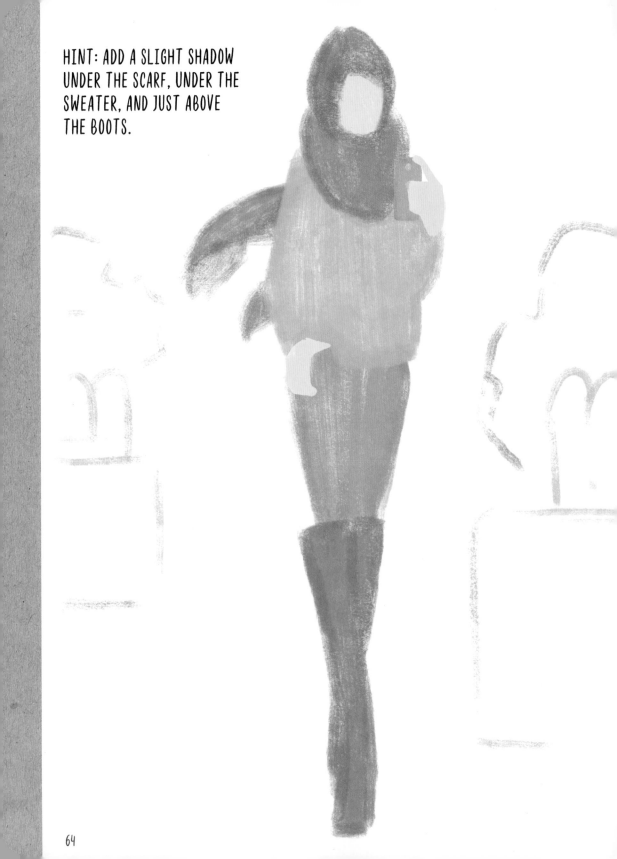

HINT: ADD A SLIGHT SHADOW UNDER THE SCARF, UNDER THE SWEATER, AND JUST ABOVE THE BOOTS.

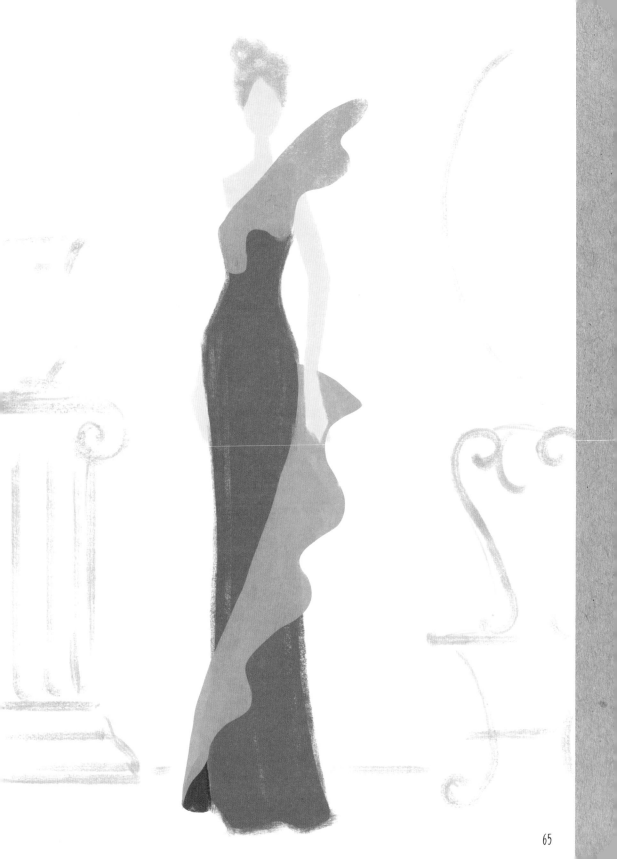

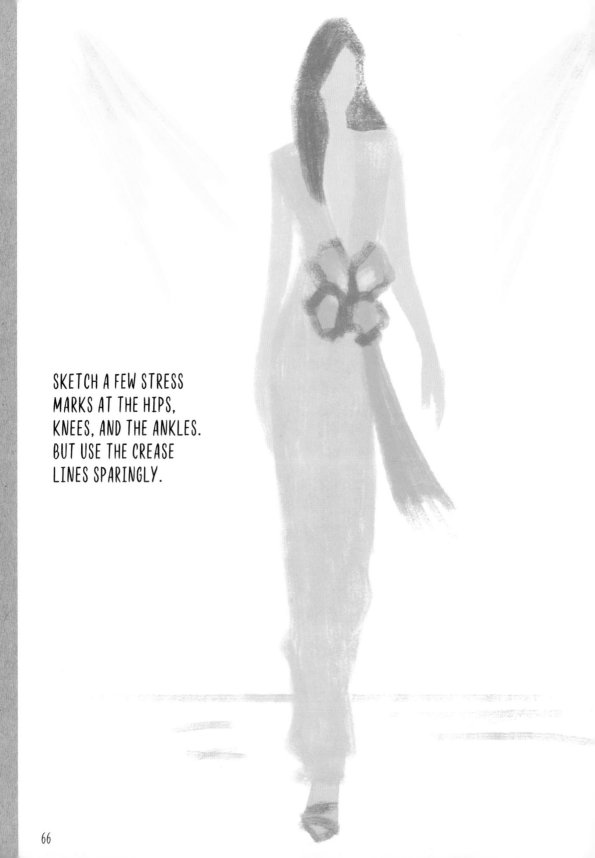

SKETCH A FEW STRESS
MARKS AT THE HIPS,
KNEES, AND THE ANKLES.
BUT USE THE CREASE
LINES SPARINGLY.

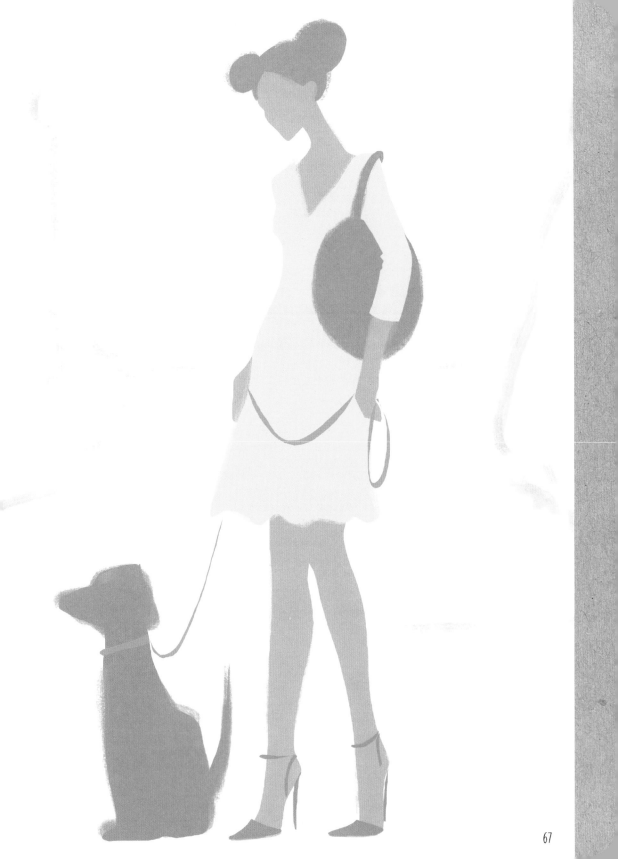

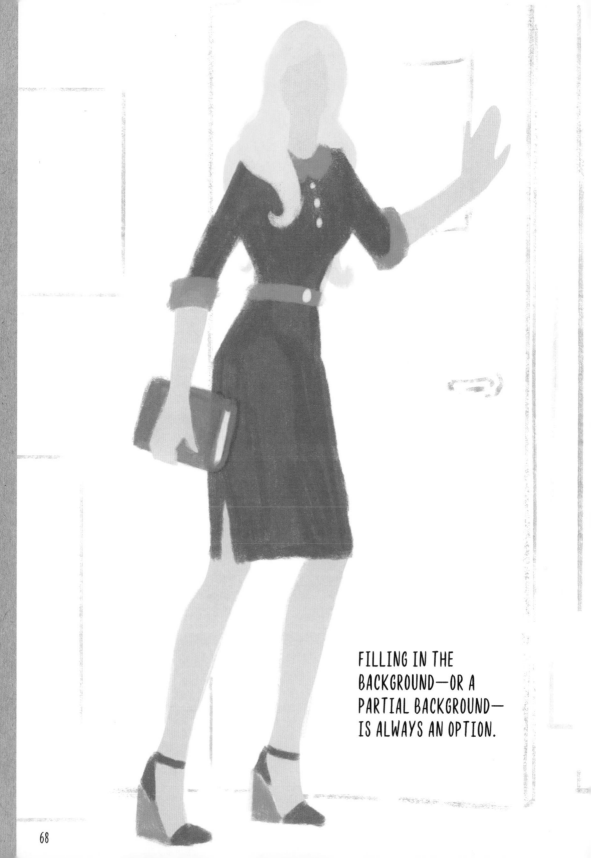

FILLING IN THE
BACKGROUND—OR A
PARTIAL BACKGROUND—
IS ALWAYS AN OPTION.

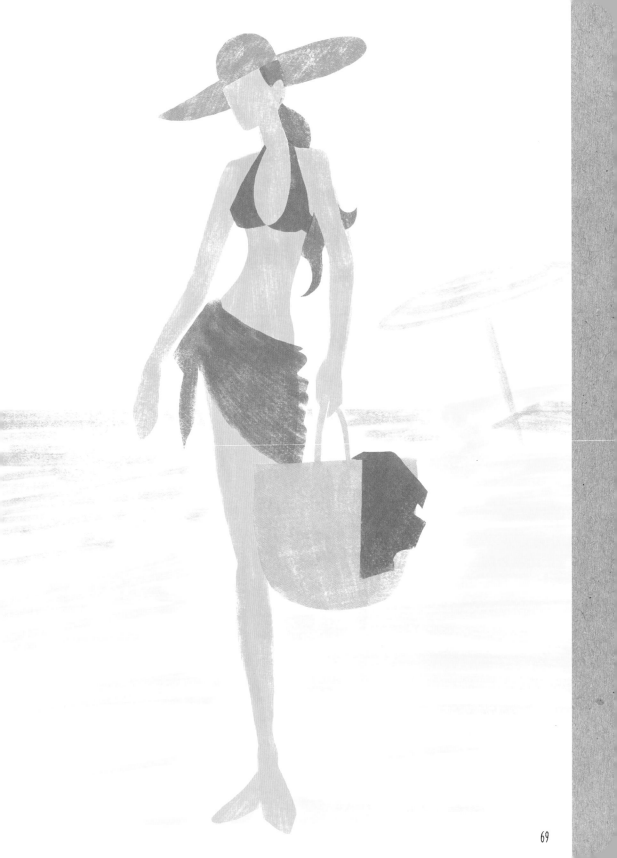

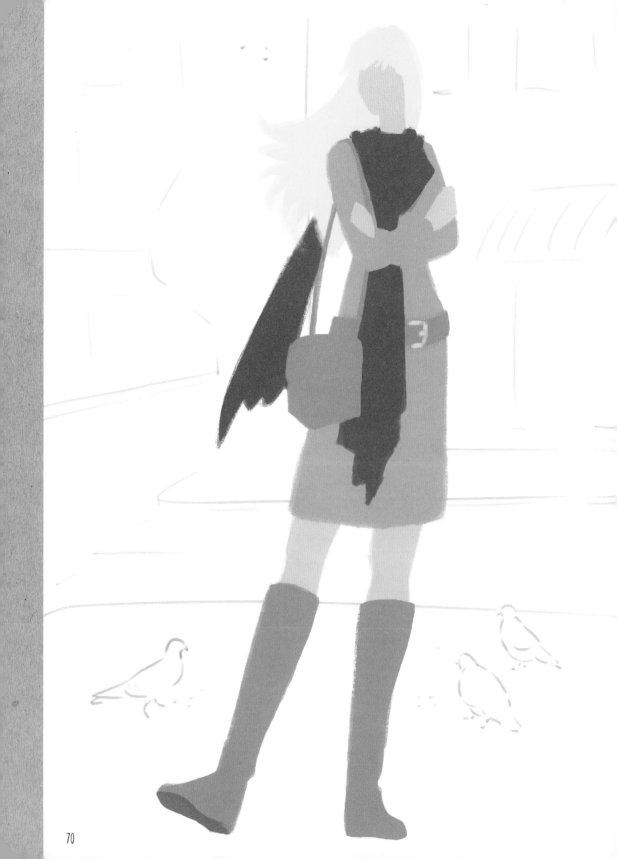

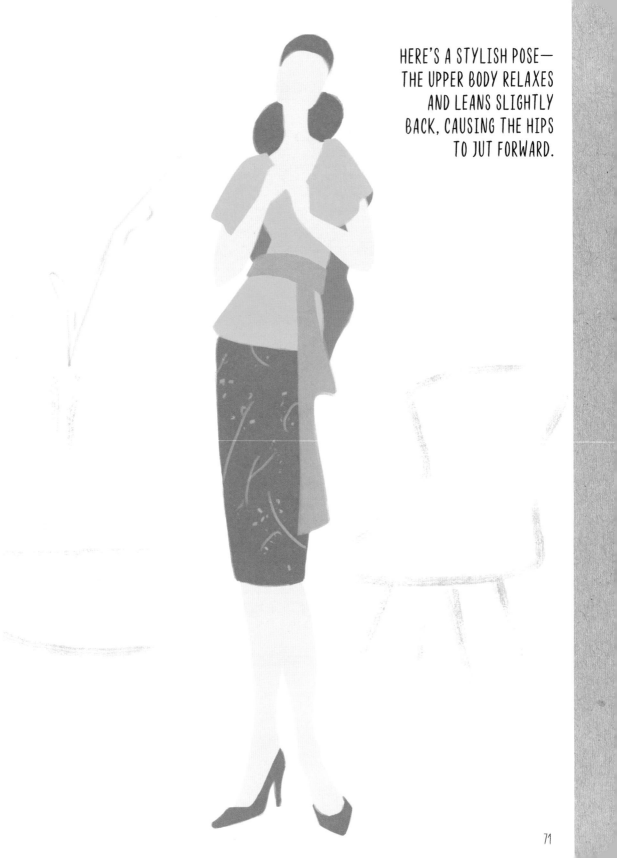

HERE'S A STYLISH POSE—
THE UPPER BODY RELAXES
AND LEANS SLIGHTLY
BACK, CAUSING THE HIPS
TO JUT FORWARD.

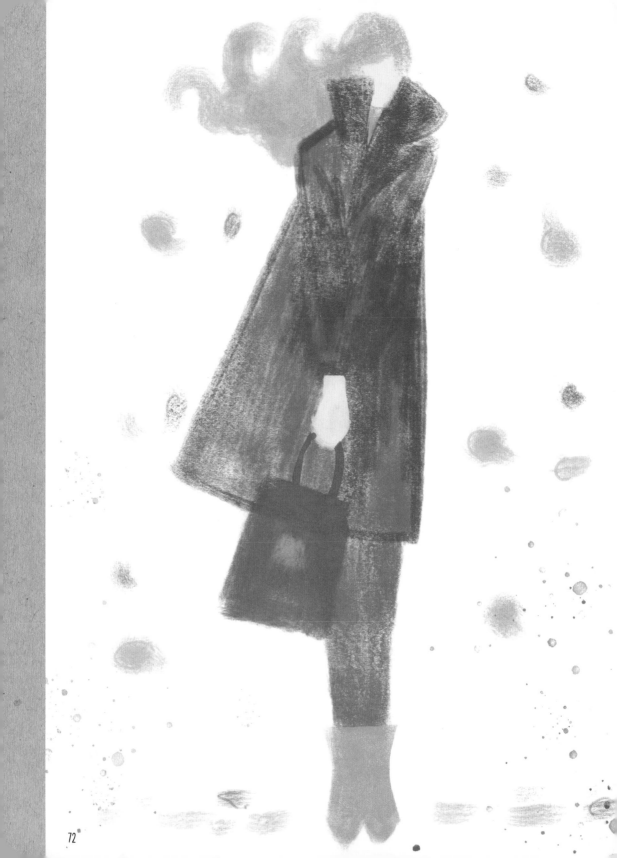

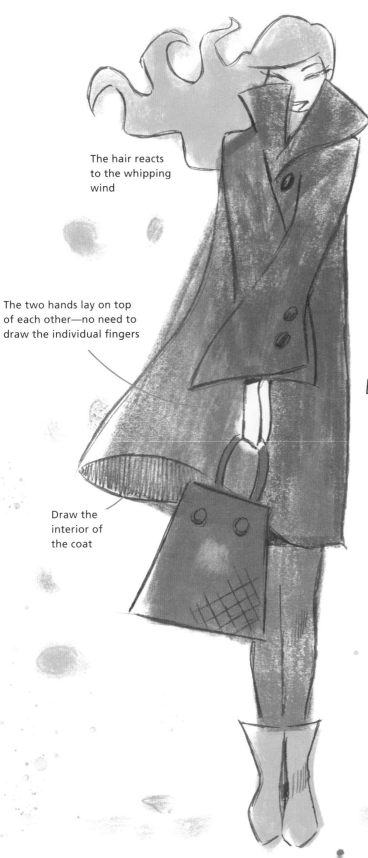

Give her a large, raised collar

The hair reacts to the whipping wind

The two hands lay on top of each other—no need to draw the individual fingers

Draw the interior of the coat

MY TURN!

THE COOL AUTUMN BREEZE CAUSES THIS FIGURE TO PULL IN HER ARMS AND LEGS. THE WIND WHIPS UP THE LEAVES. ENJOY THEM WHILE YOU CAN. IN TWO WEEKS, YOUR LANDSCAPER WILL CHARGE YOU A FORTUNE TO CLEAN THEM FROM YOUR FRONT LAWN.

LET'S TAKE A QUICK
DETOUR TO THE WESTERN
UNITED STATES. NO
PARKING METERS, BUT
SHE STILL HAS TO PUT A
QUARTER IN THE CACTUS.

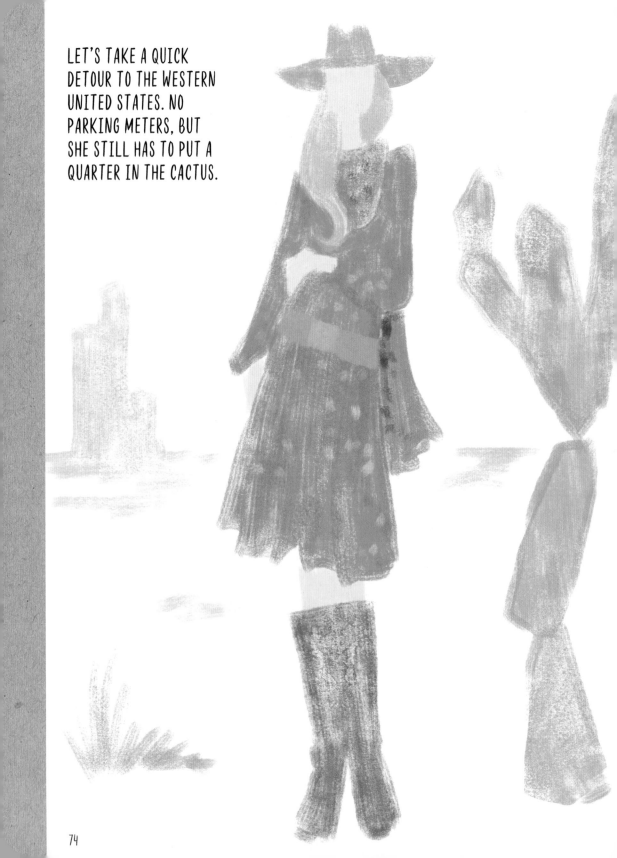

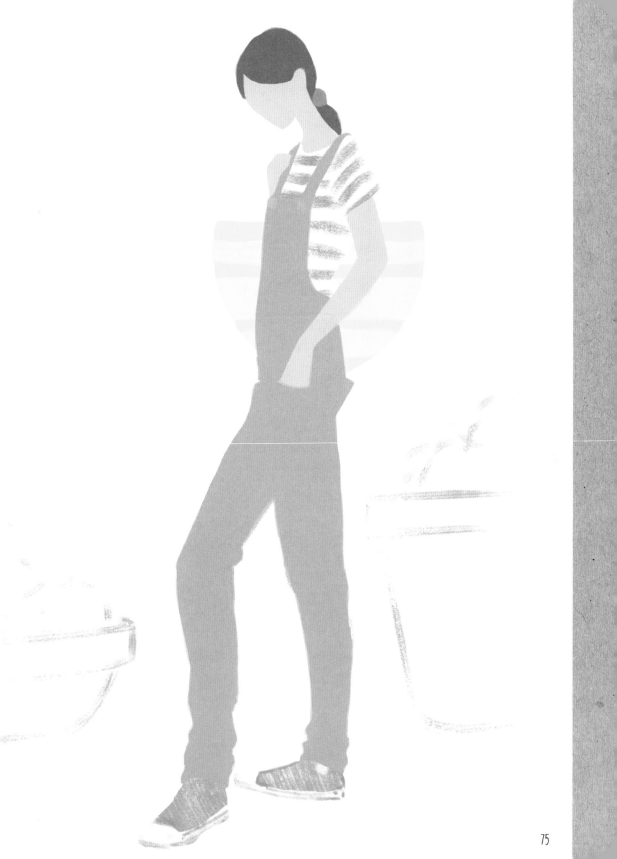

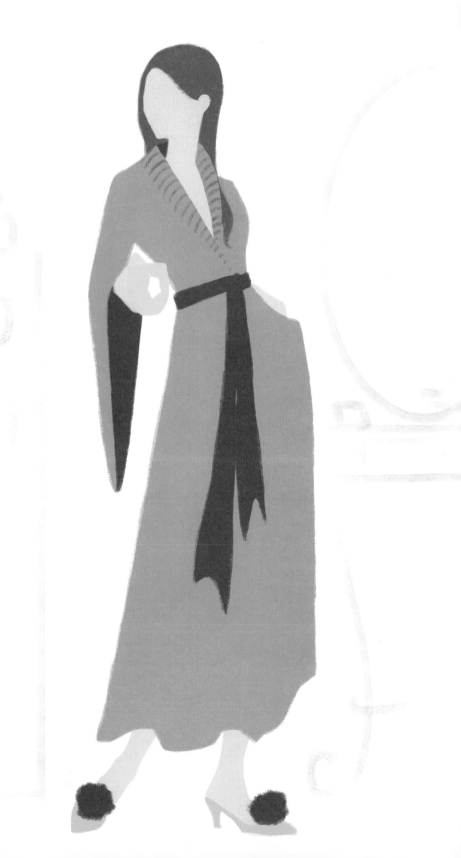

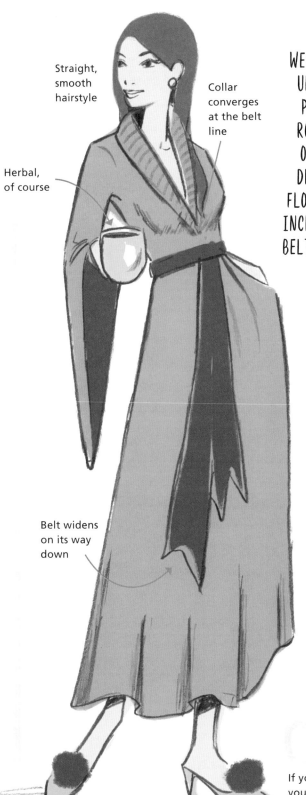

Straight, smooth hairstyle

Collar converges at the belt line

Herbal, of course

Belt widens on its way down

MY TURN!
WELCOME TO AN ALTERNATE UNIVERSE, ONE IN WHICH PEOPLE LOOK THIS GOOD ROLLING OUT OF BED. THE OVERALL THEME OF THIS DRAWING IS A DOWNWARD FLOW OF VARIOUS ELEMENTS, INCLUDING THE HAIR, SLEEVE, BELT, AND ROBE. IT GIVES THE FIGURE A SLEEK LOOK.

If you wear slippers like this, you ought to be in this book

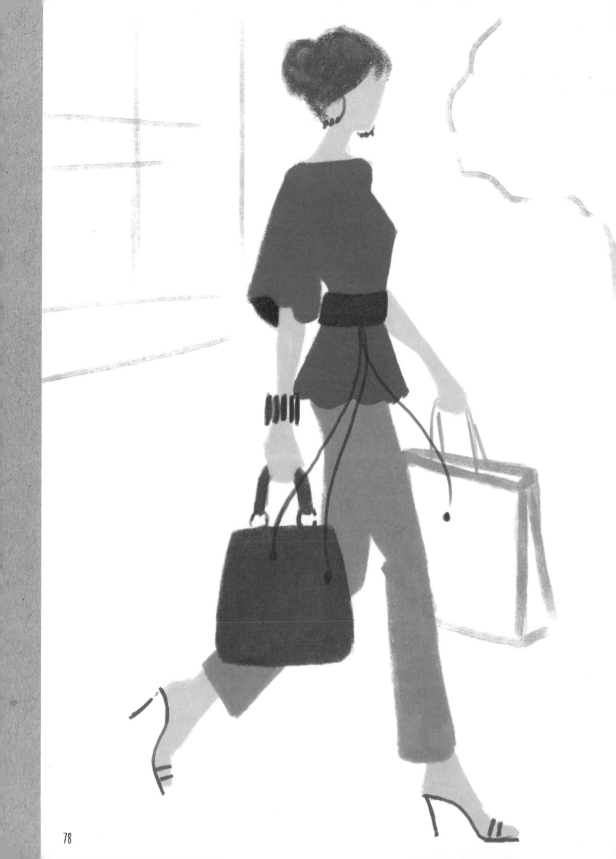

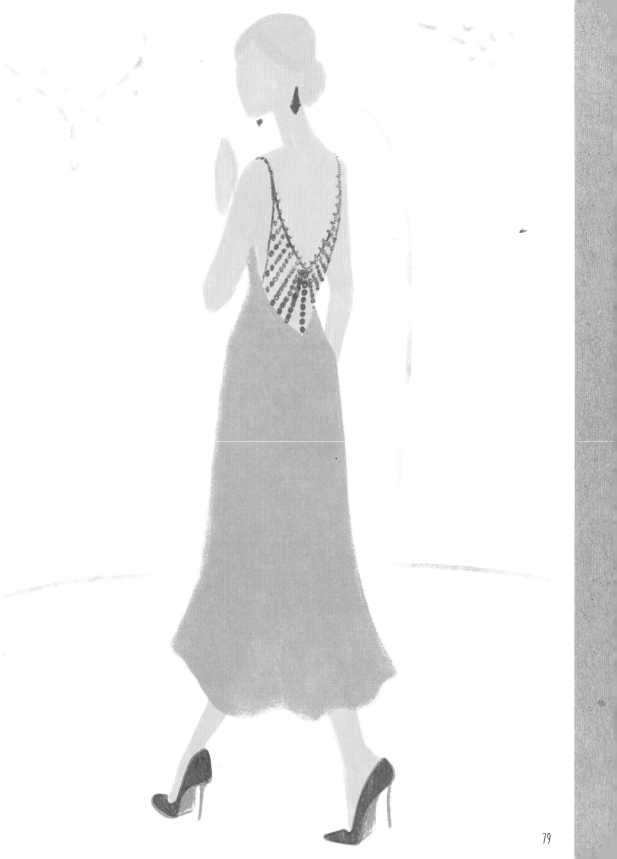

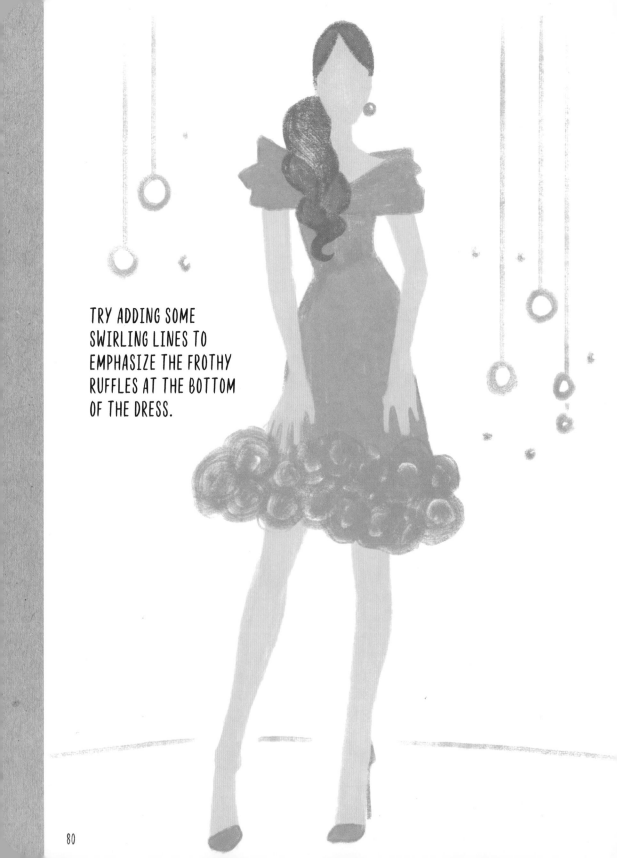

TRY ADDING SOME
SWIRLING LINES TO
EMPHASIZE THE FROTHY
RUFFLES AT THE BOTTOM
OF THE DRESS.

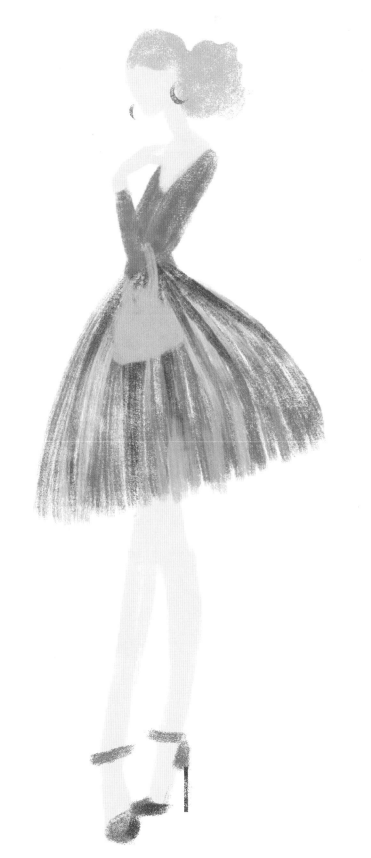

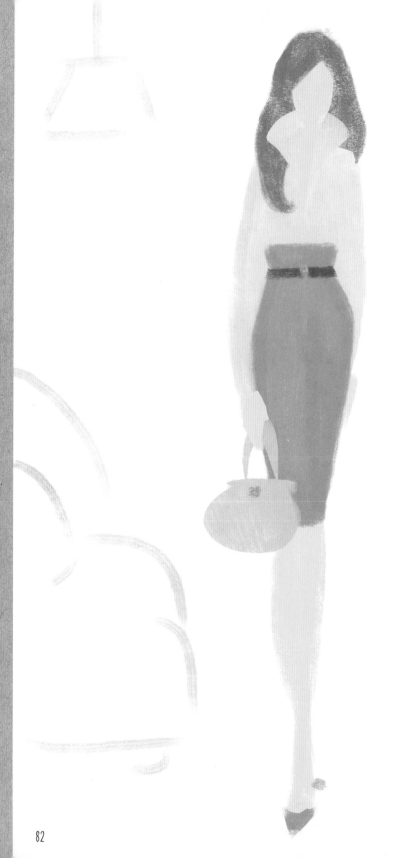

THIS FIGURE IS COOL AND IN CONTROL. DESIGNING THE WIDE COLLAR WILL GIVE HER EVEN MORE EDGE.

SHE'S TAKING HER
BIKE FOR A SPIN IN
SUMMER. WHAT TYPE OF
EXPRESSION WILL YOU
DRAW?

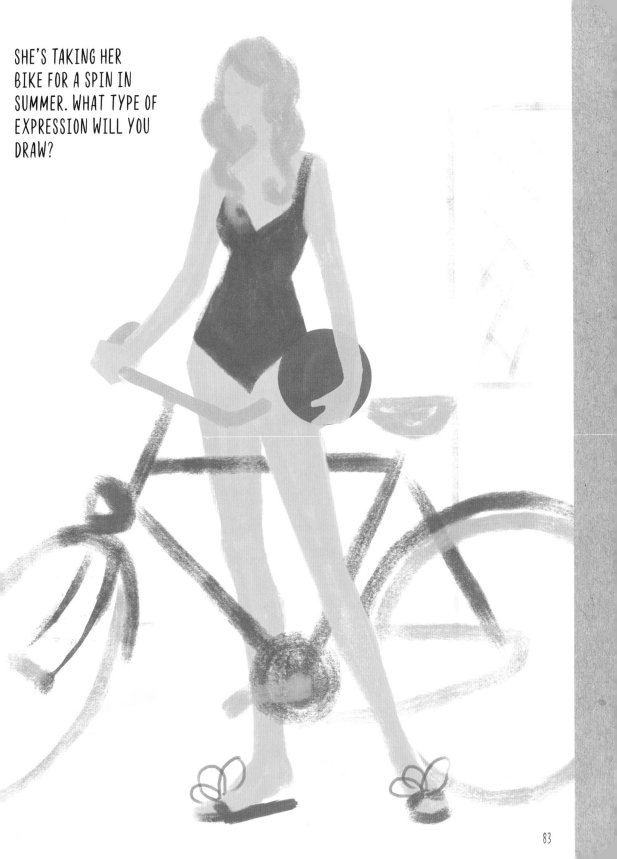

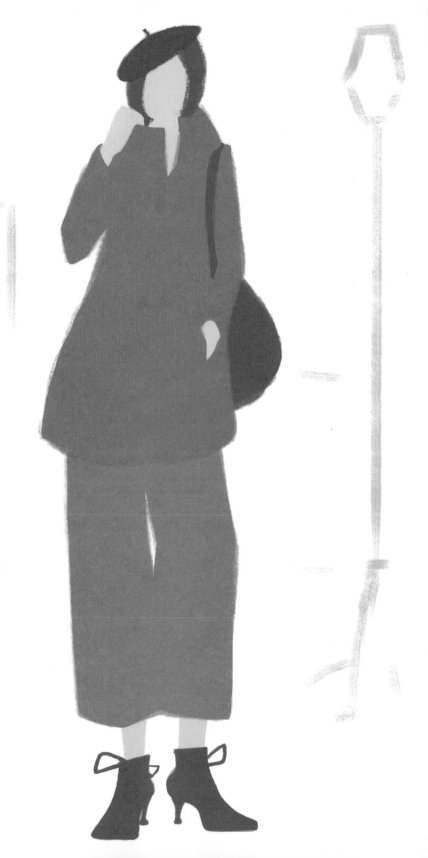

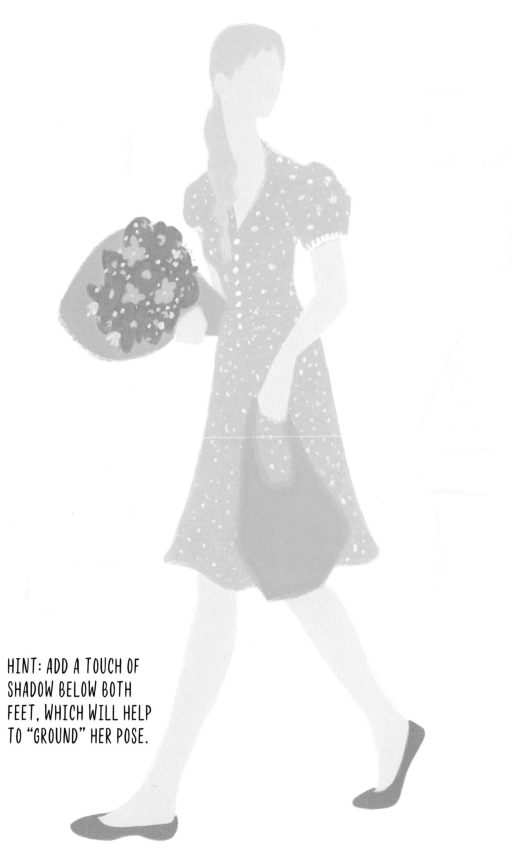

HINT: ADD A TOUCH OF SHADOW BELOW BOTH FEET, WHICH WILL HELP TO "GROUND" HER POSE.

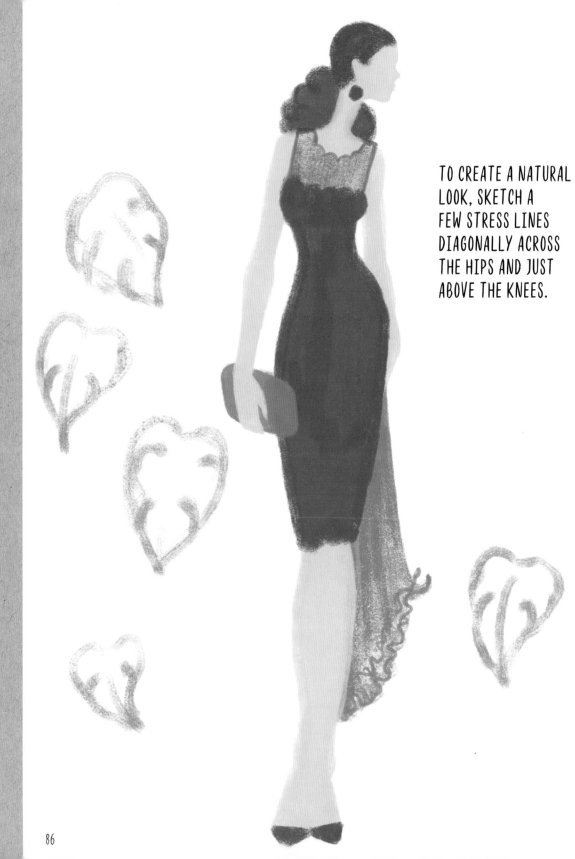

TO CREATE A NATURAL LOOK, SKETCH A FEW STRESS LINES DIAGONALLY ACROSS THE HIPS AND JUST ABOVE THE KNEES.

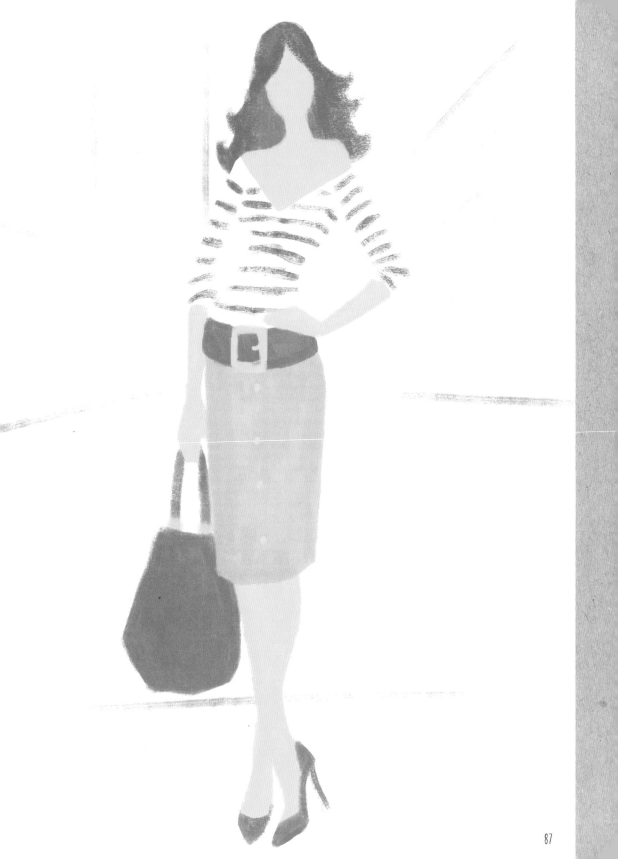

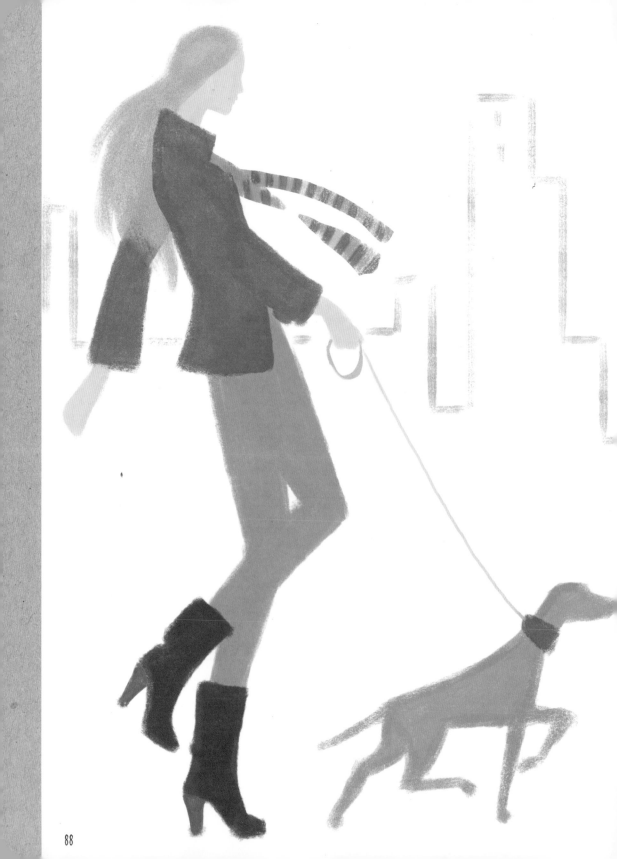

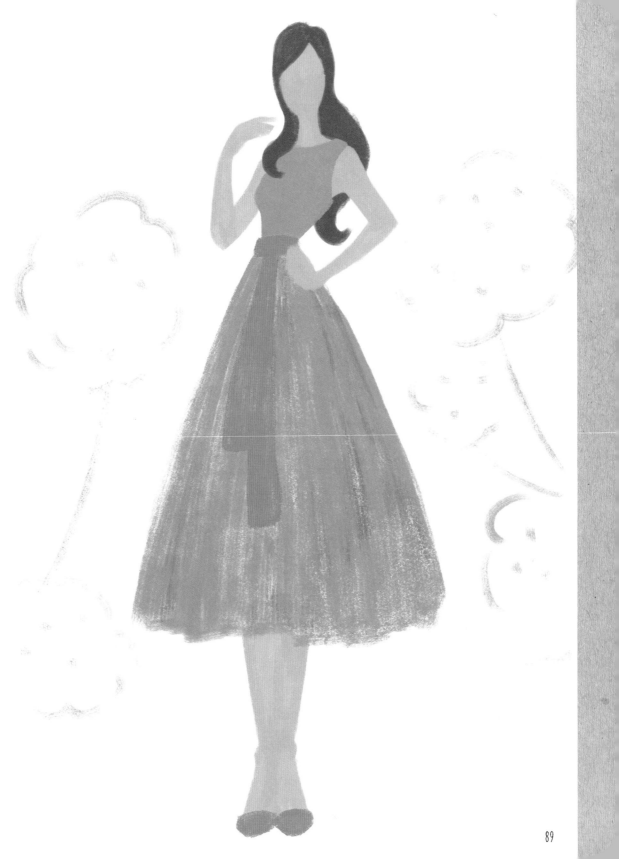

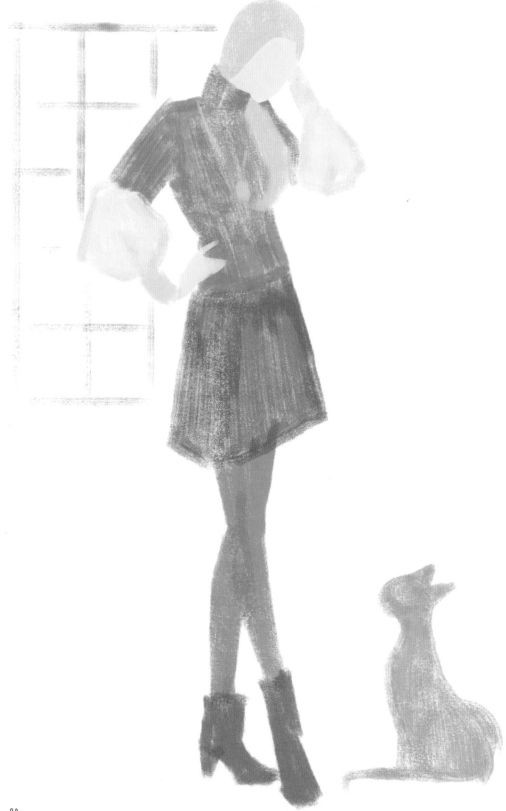

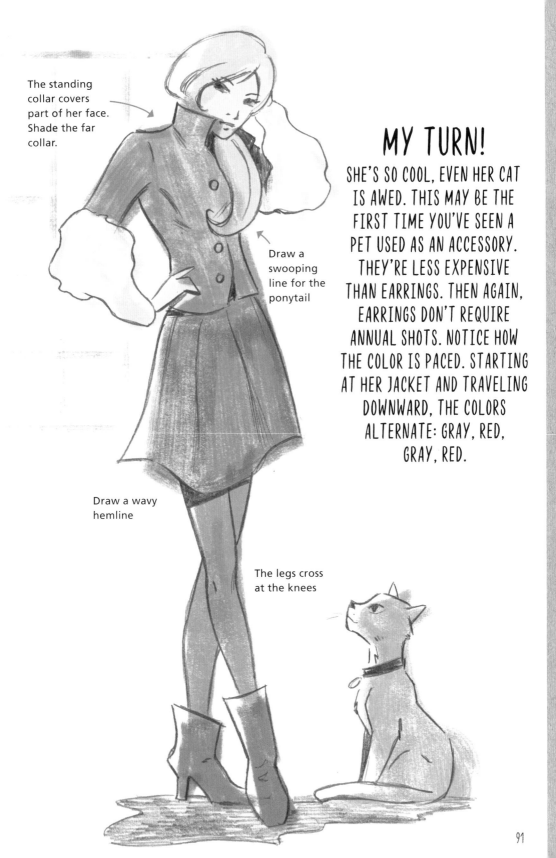

The standing collar covers part of her face. Shade the far collar.

Draw a swooping line for the ponytail

Draw a wavy hemline

The legs cross at the knees

MY TURN!

SHE'S SO COOL, EVEN HER CAT IS AWED. THIS MAY BE THE FIRST TIME YOU'VE SEEN A PET USED AS AN ACCESSORY. THEY'RE LESS EXPENSIVE THAN EARRINGS. THEN AGAIN, EARRINGS DON'T REQUIRE ANNUAL SHOTS. NOTICE HOW THE COLOR IS PACED. STARTING AT HER JACKET AND TRAVELING DOWNWARD, THE COLORS ALTERNATE: GRAY, RED, GRAY, RED.

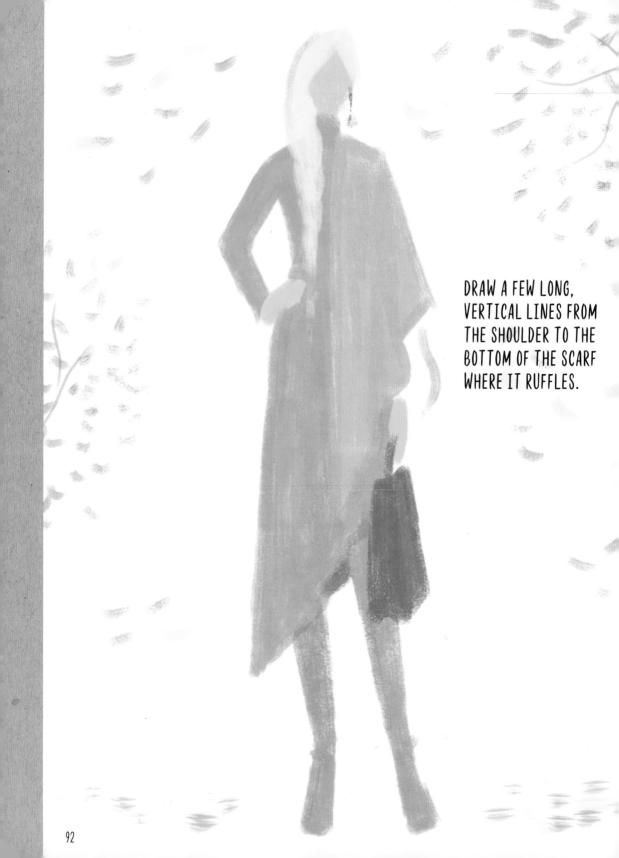

DRAW A FEW LONG, VERTICAL LINES FROM THE SHOULDER TO THE BOTTOM OF THE SCARF WHERE IT RUFFLES.

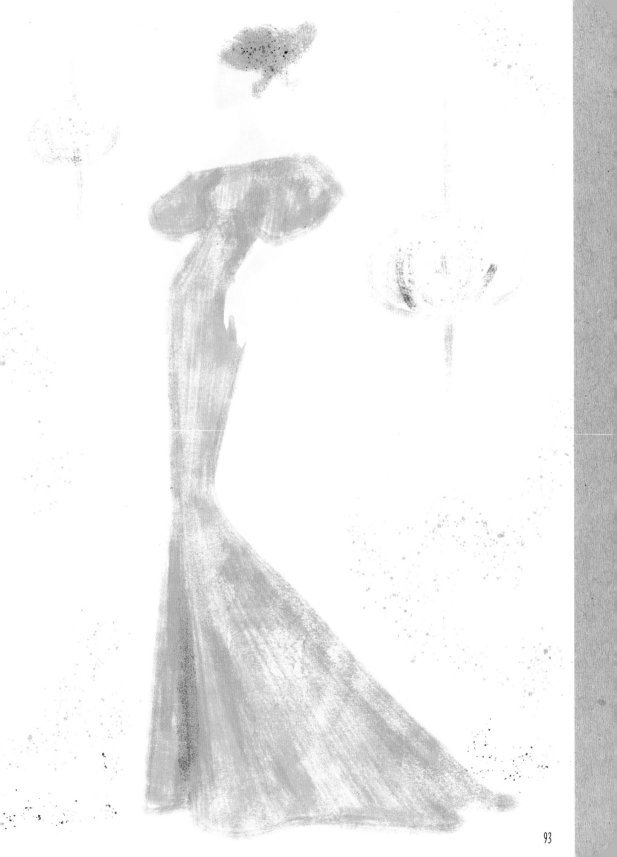

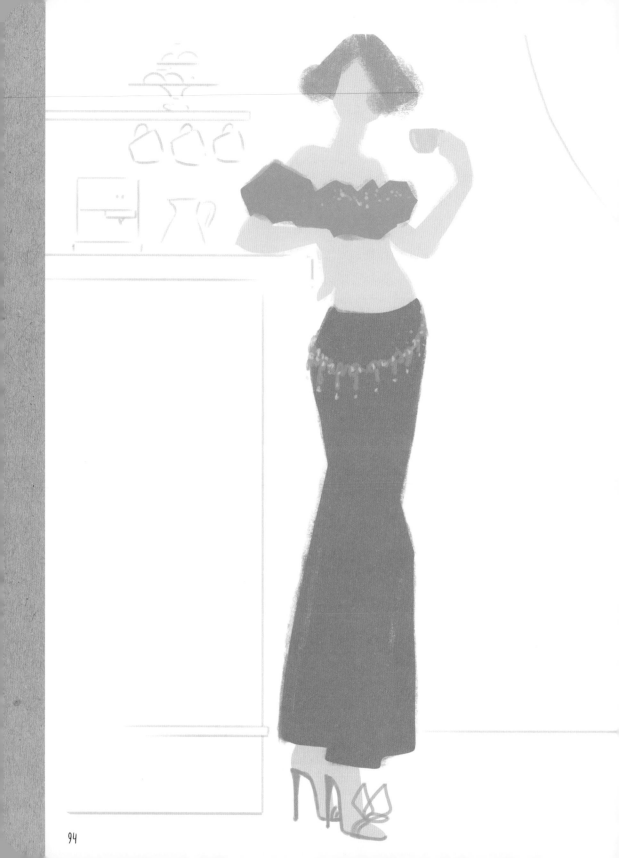

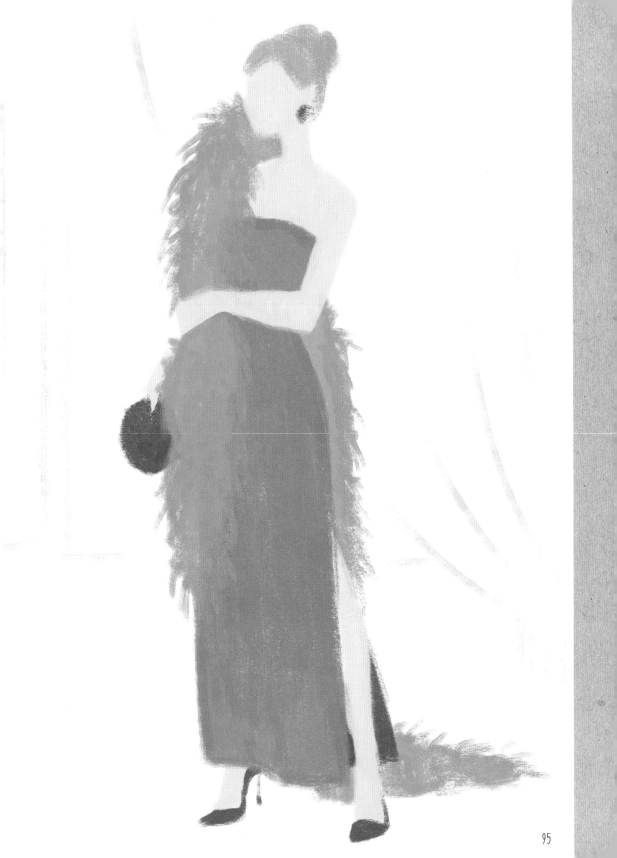

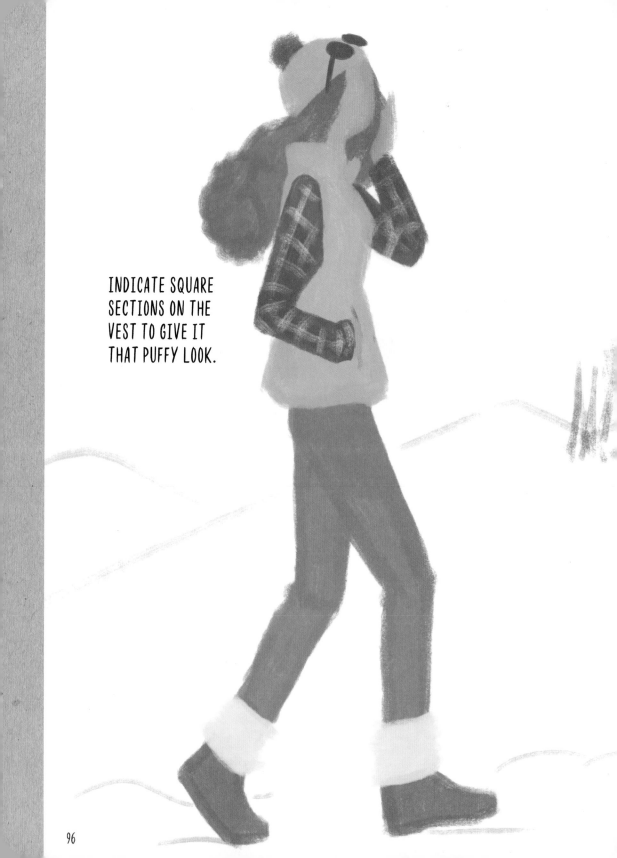

INDICATE SQUARE
SECTIONS ON THE
VEST TO GIVE IT
THAT PUFFY LOOK.

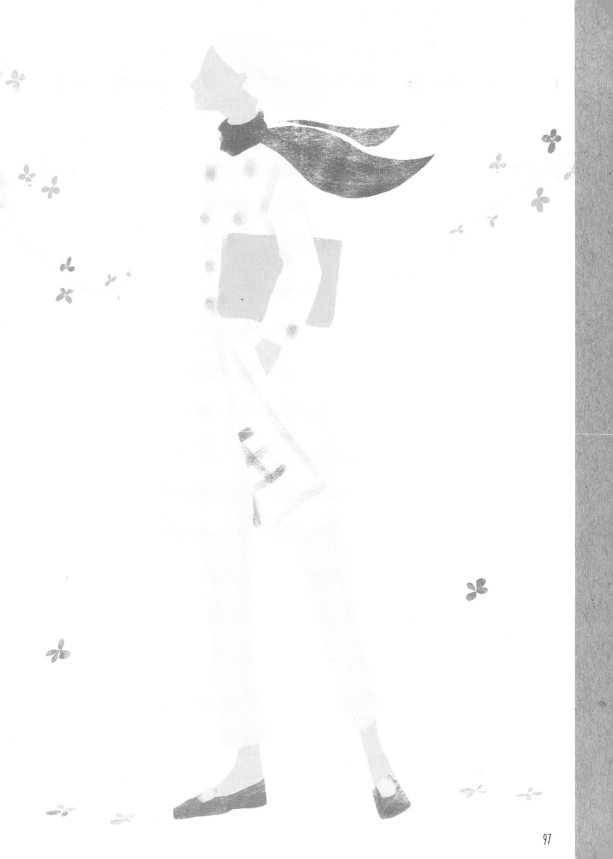

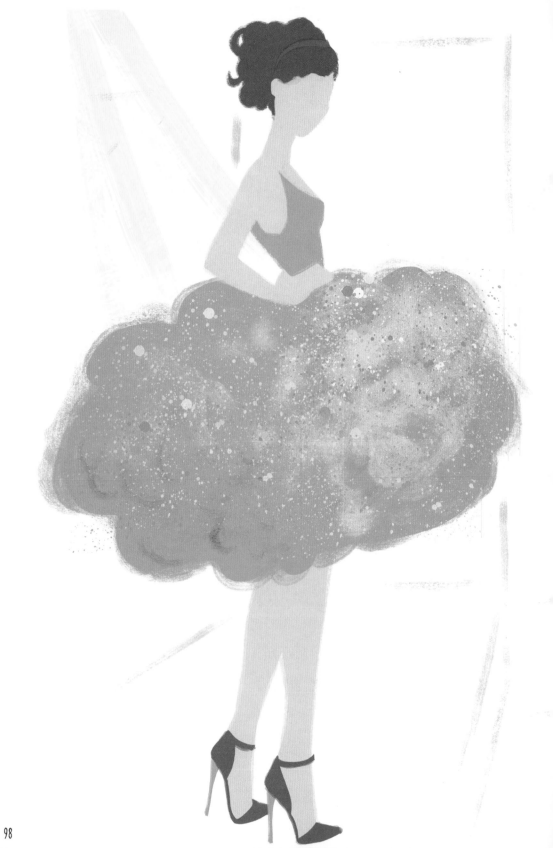

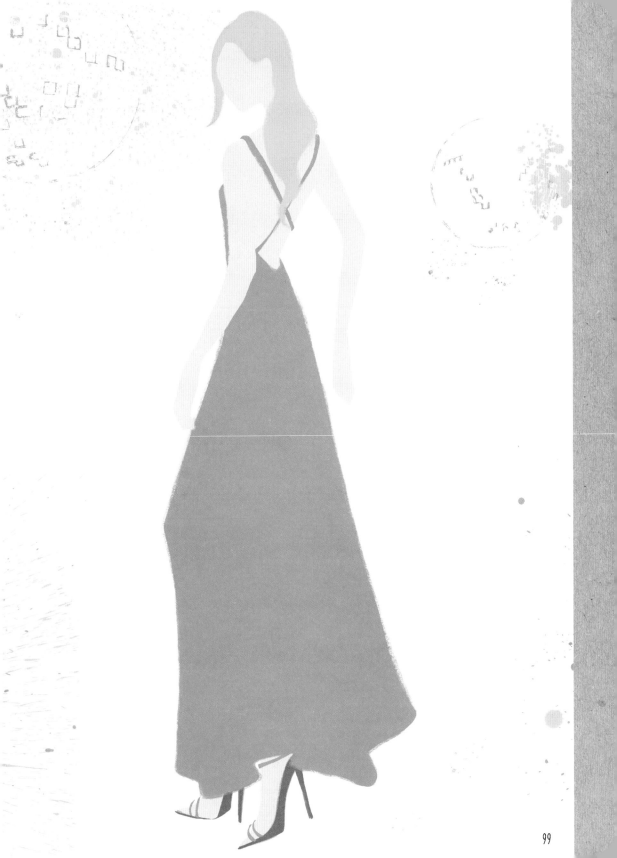

ADD SOME DEFINITION
TO THE HAIR BY
DRAWING A FEW
INDIVIDUAL STRANDS.

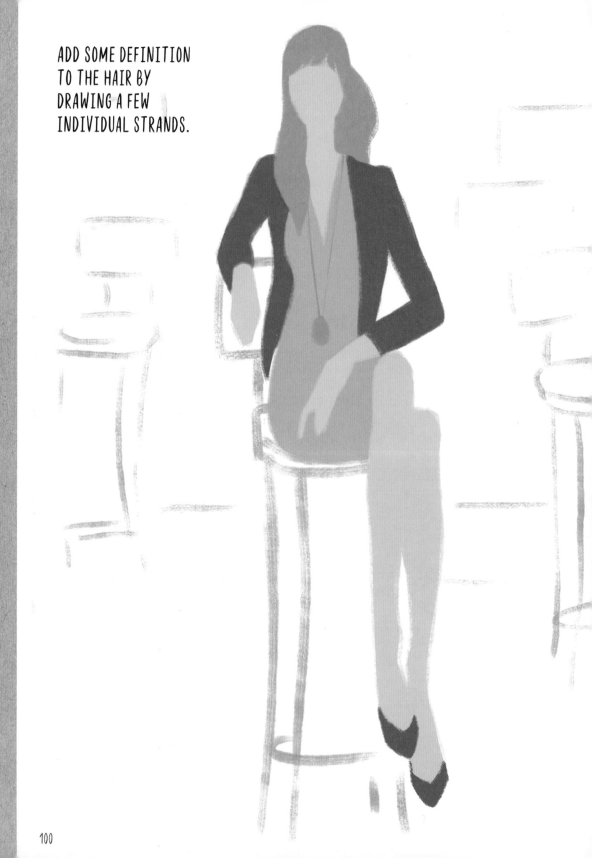

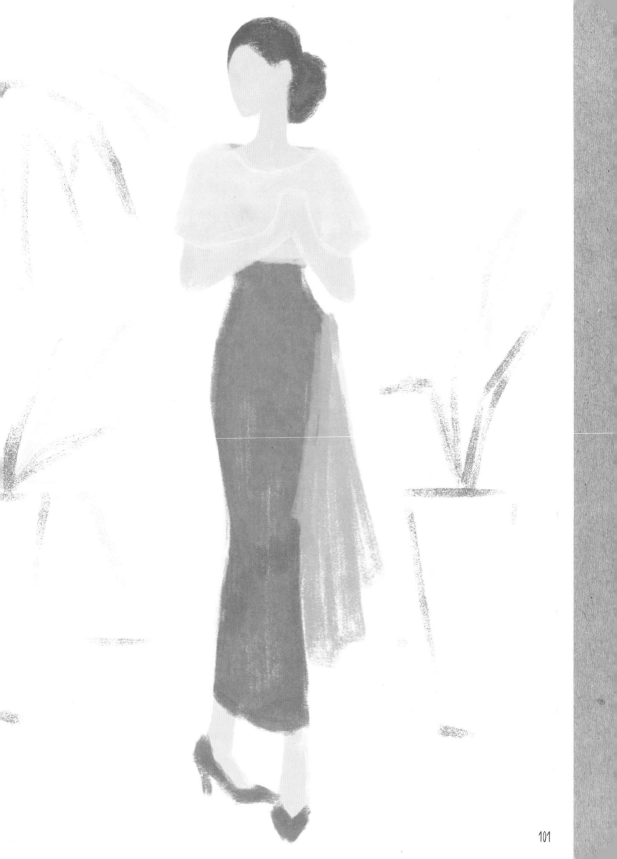

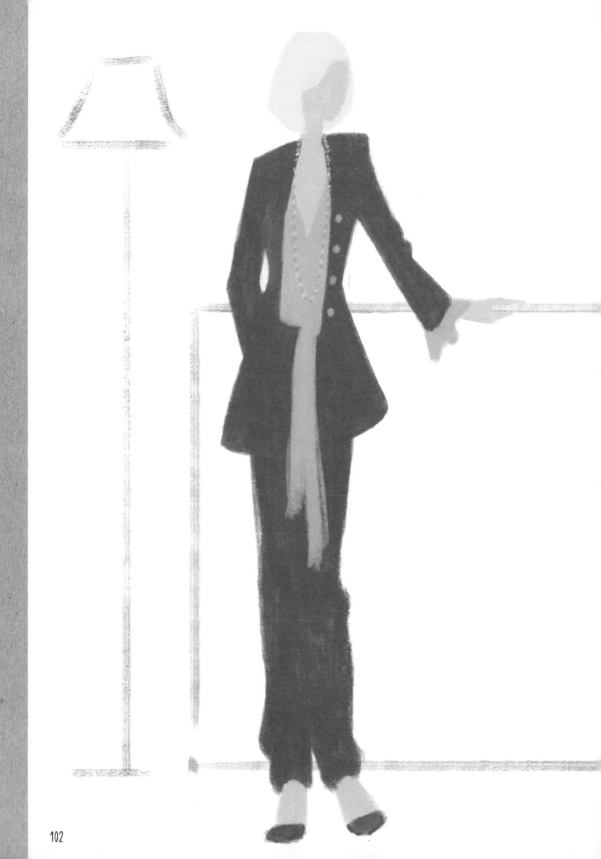

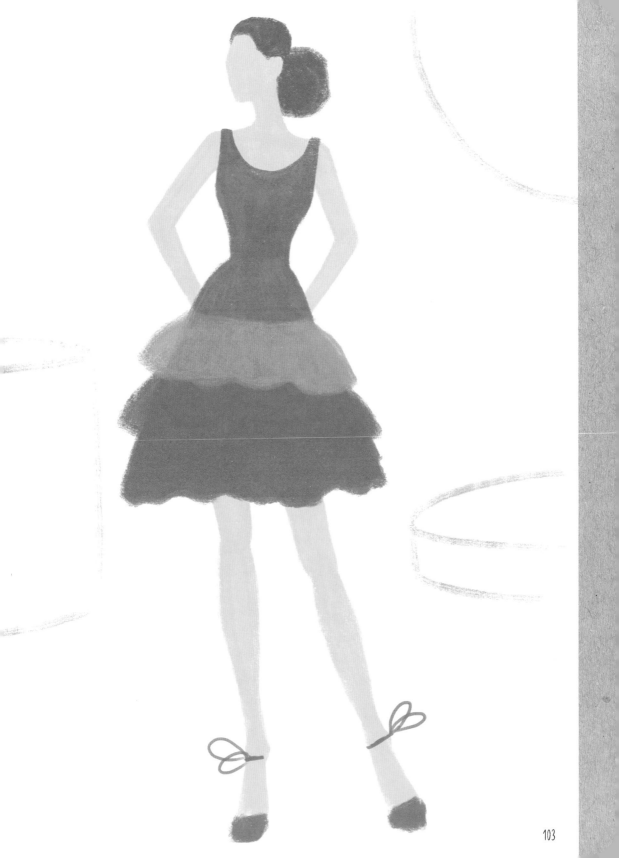

TO SHOW SHE'S SPEAKING INTO A CELL PHONE, ALL YOU NEED TO DRAW IS A SMALL, OPEN-MOUTH SMILE.

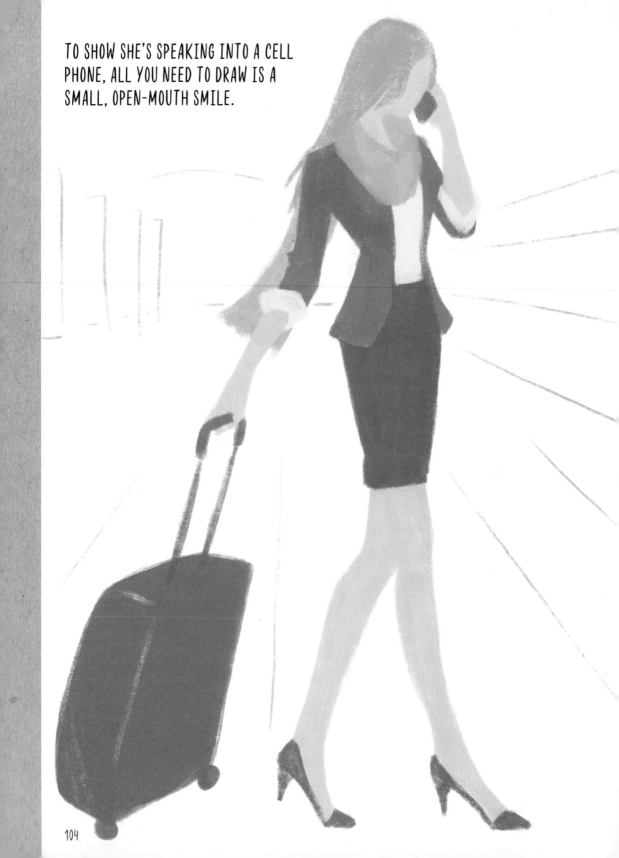

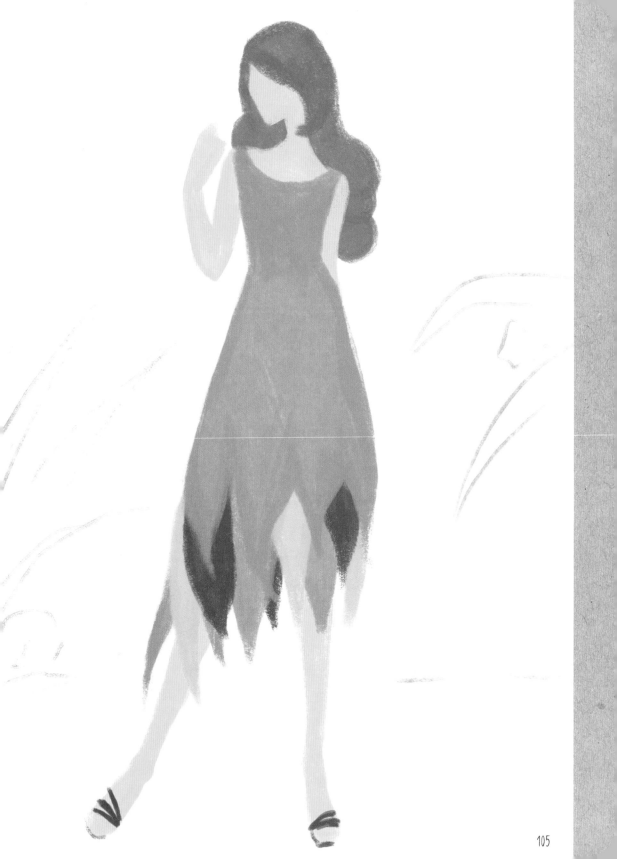

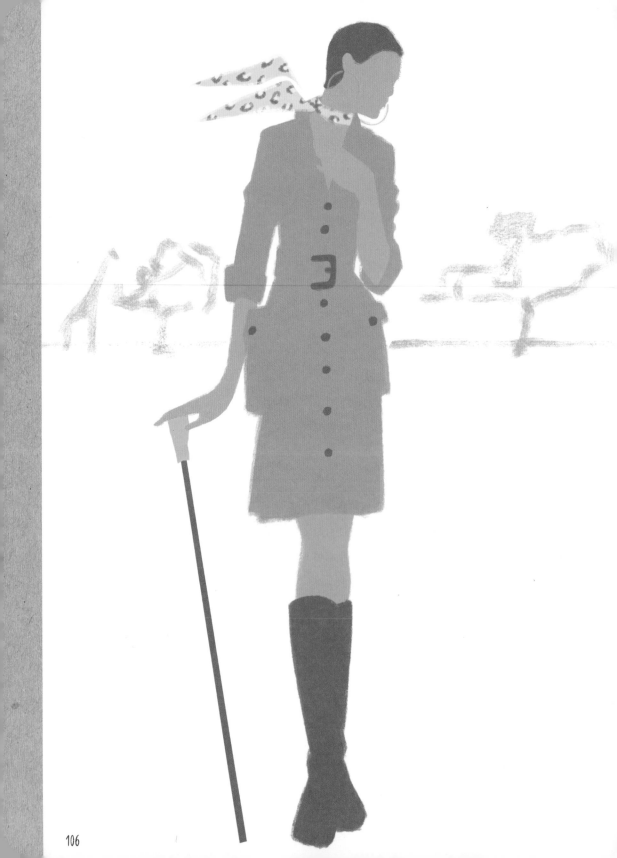

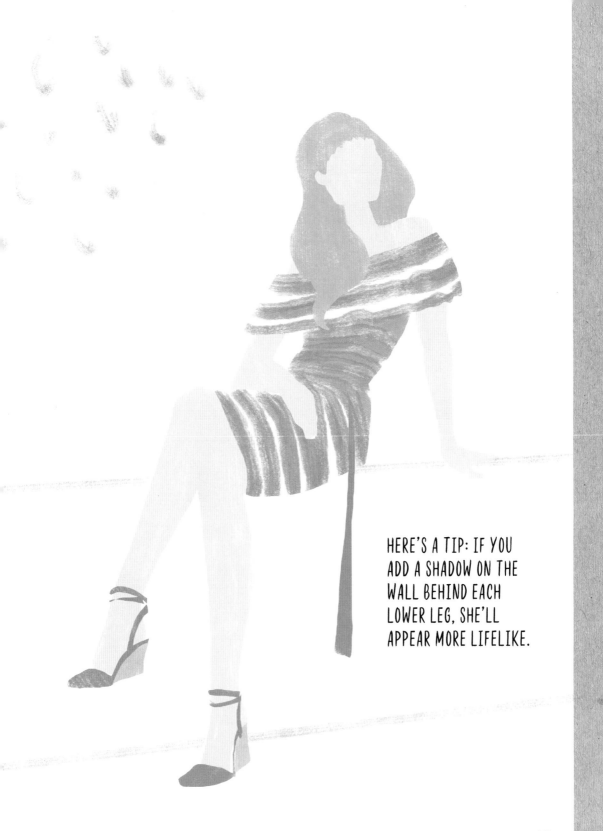

HERE'S A TIP: IF YOU ADD A SHADOW ON THE WALL BEHIND EACH LOWER LEG, SHE'LL APPEAR MORE LIFELIKE.

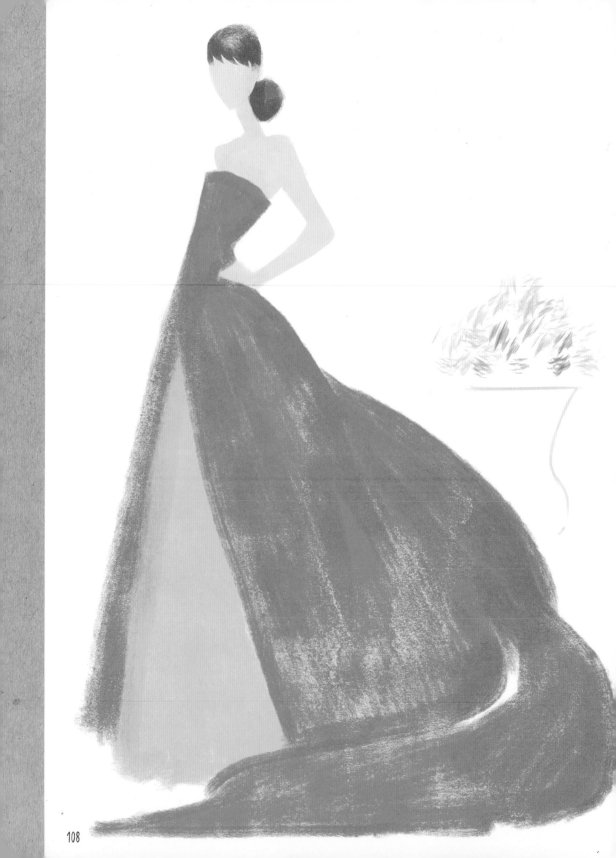

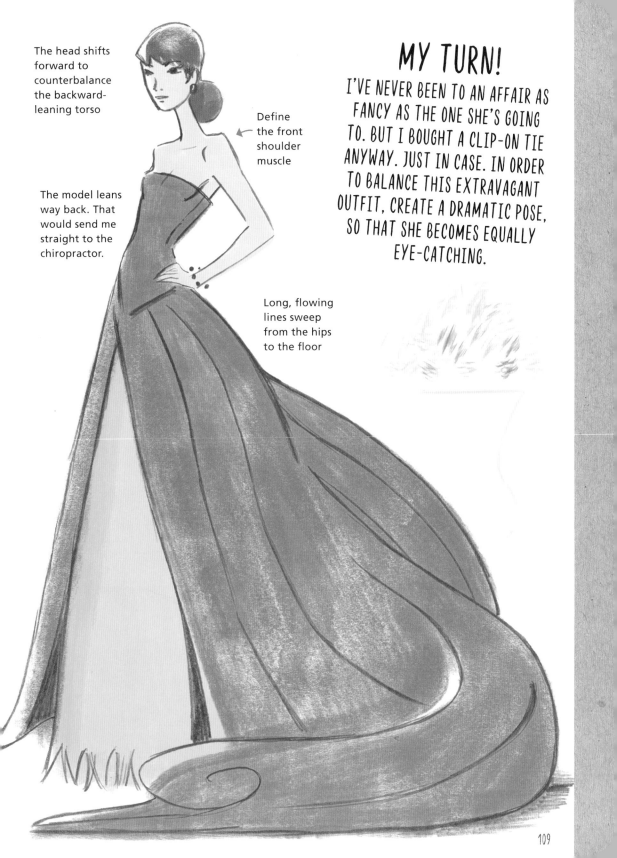

The head shifts forward to counterbalance the backward-leaning torso

Define the front shoulder muscle

The model leans way back. That would send me straight to the chiropractor.

Long, flowing lines sweep from the hips to the floor

MY TURN!

I'VE NEVER BEEN TO AN AFFAIR AS FANCY AS THE ONE SHE'S GOING TO. BUT I BOUGHT A CLIP-ON TIE ANYWAY. JUST IN CASE. IN ORDER TO BALANCE THIS EXTRAVAGANT OUTFIT, CREATE A DRAMATIC POSE, SO THAT SHE BECOMES EQUALLY EYE-CATCHING.

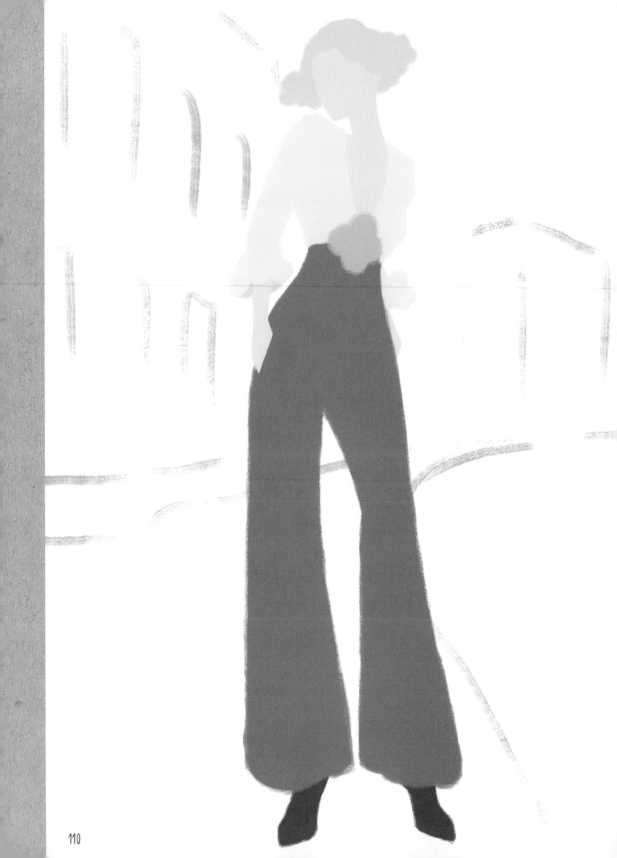

THE UMBRELLA AND THE
RAINCOAT COULD USE
YOUR INPUT. MAYBE ADD
A PATTERN?

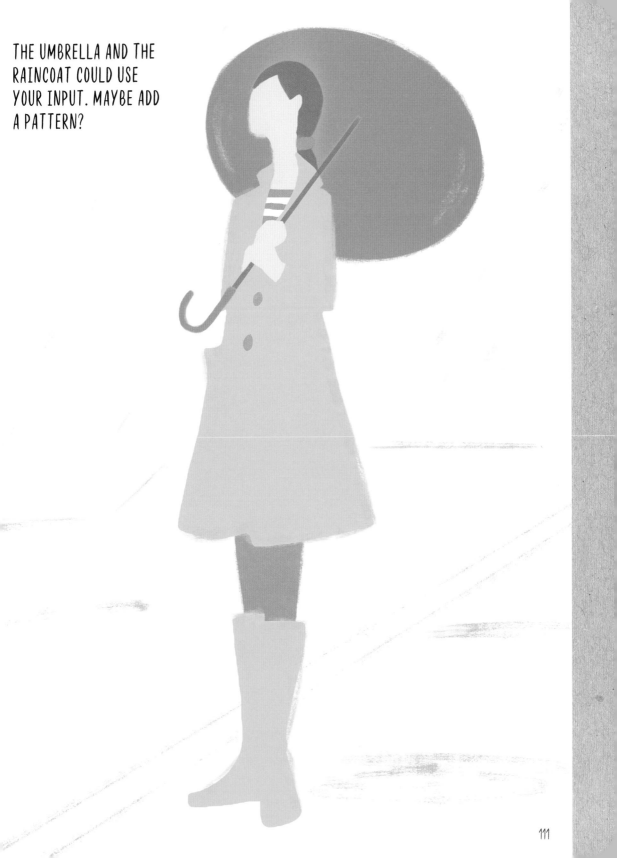

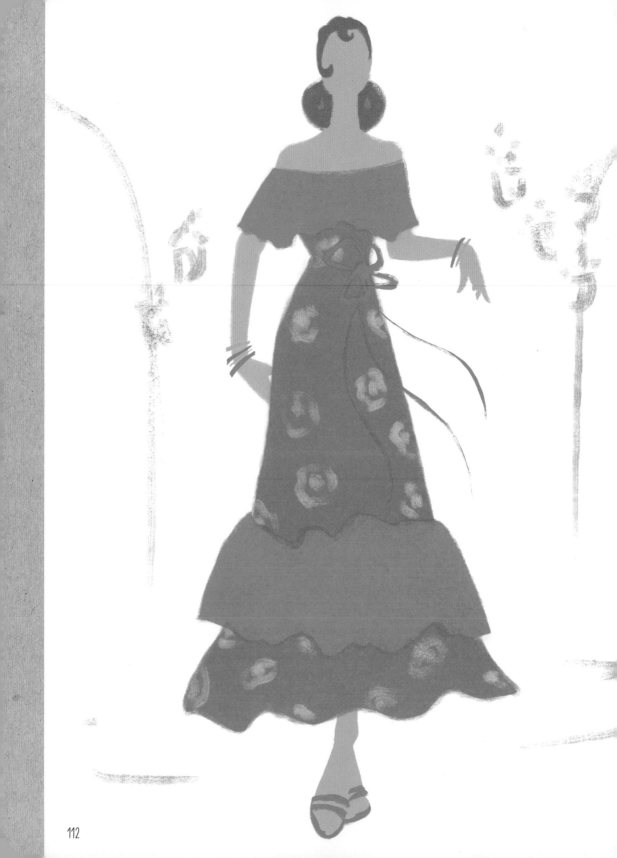

THIS ONE IS GOING
TO KEEP YOU BUSY.

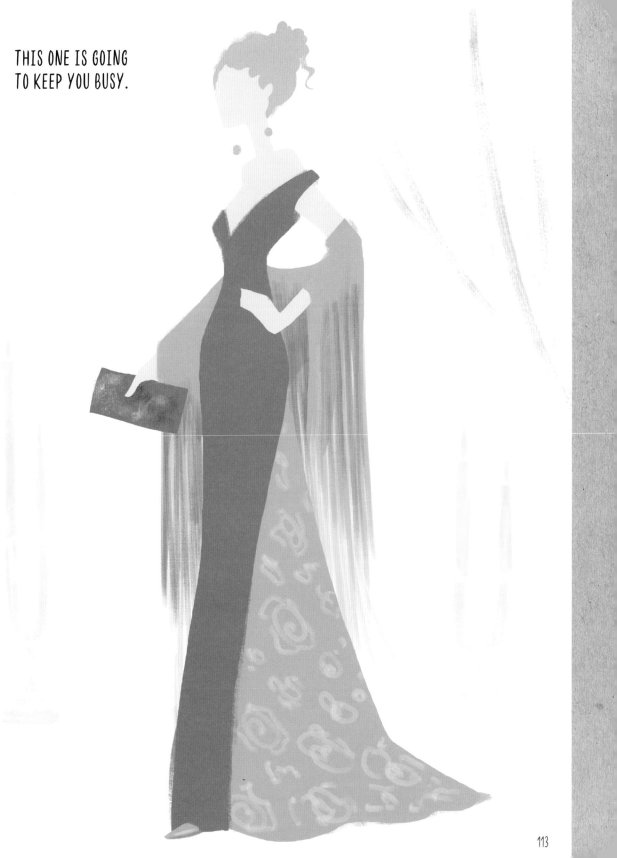

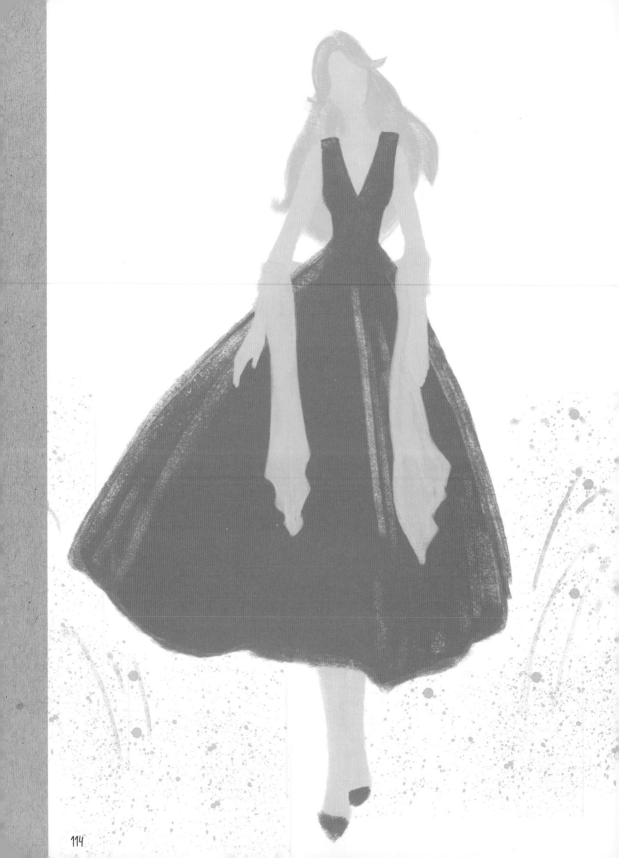

THIS FORM-FITTING
OUTFIT GIVES HER A
STYLISH, UPTOWN LOOK.

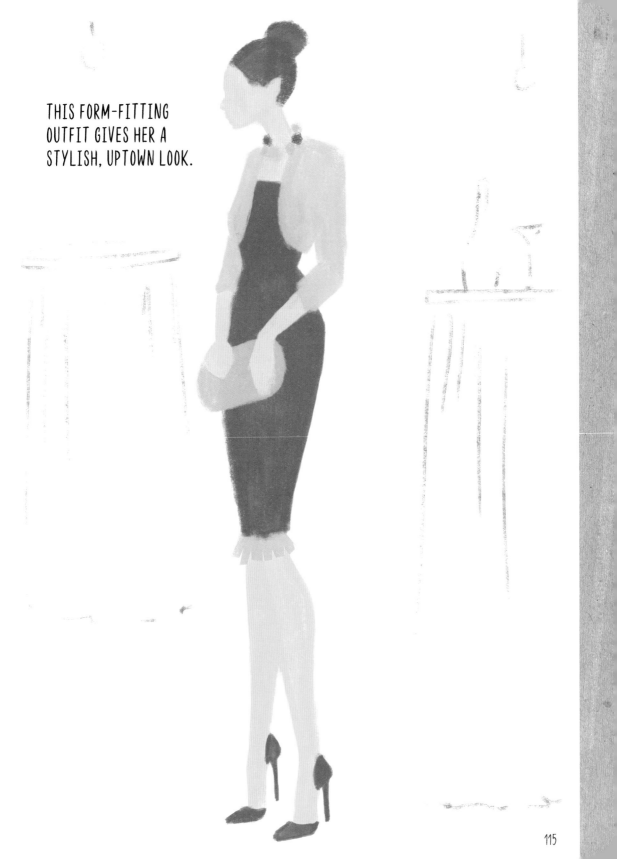

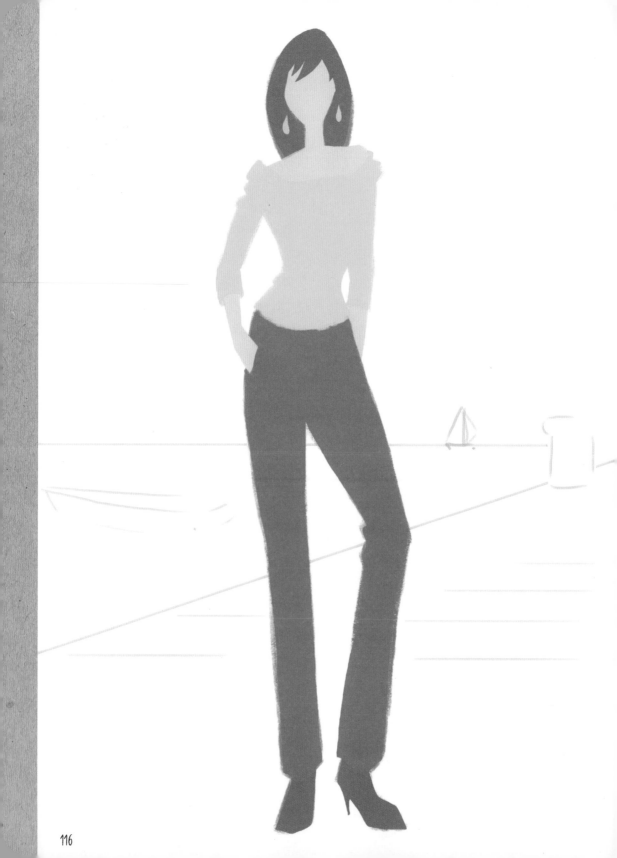

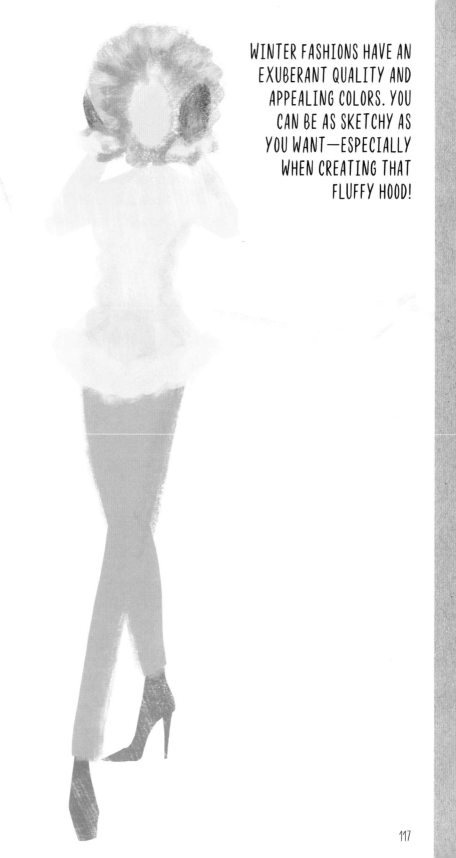

WINTER FASHIONS HAVE AN
EXUBERANT QUALITY AND
APPEALING COLORS. YOU
CAN BE AS SKETCHY AS
YOU WANT—ESPECIALLY
WHEN CREATING THAT
FLUFFY HOOD!

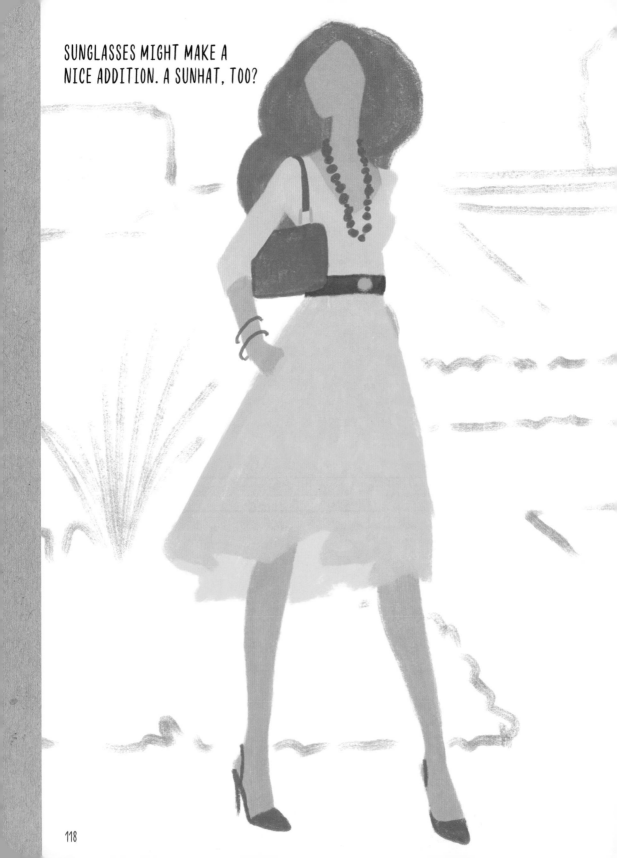

SUNGLASSES MIGHT MAKE A
NICE ADDITION. A SUNHAT, TOO?

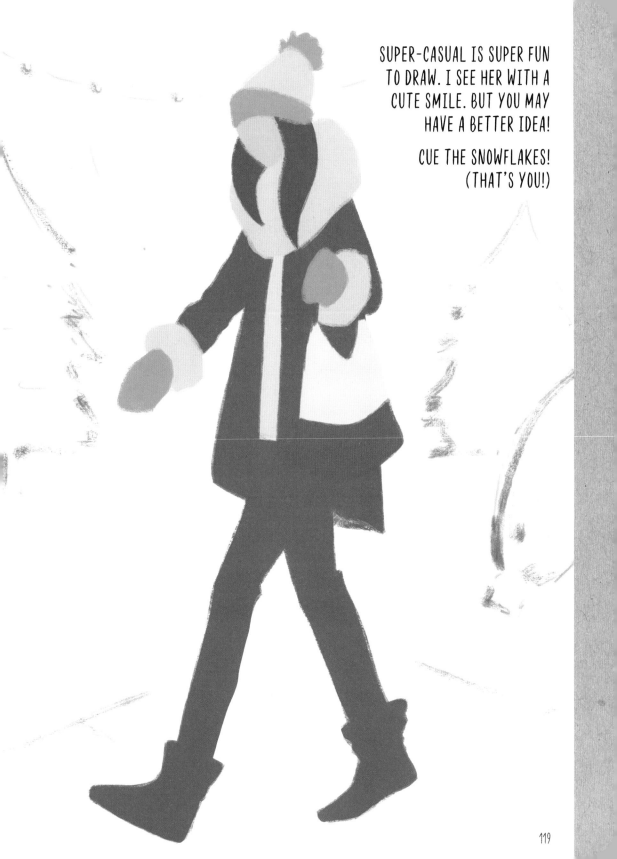

SUPER-CASUAL IS SUPER FUN TO DRAW. I SEE HER WITH A CUTE SMILE. BUT YOU MAY HAVE A BETTER IDEA!

CUE THE SNOWFLAKES! (THAT'S YOU!)

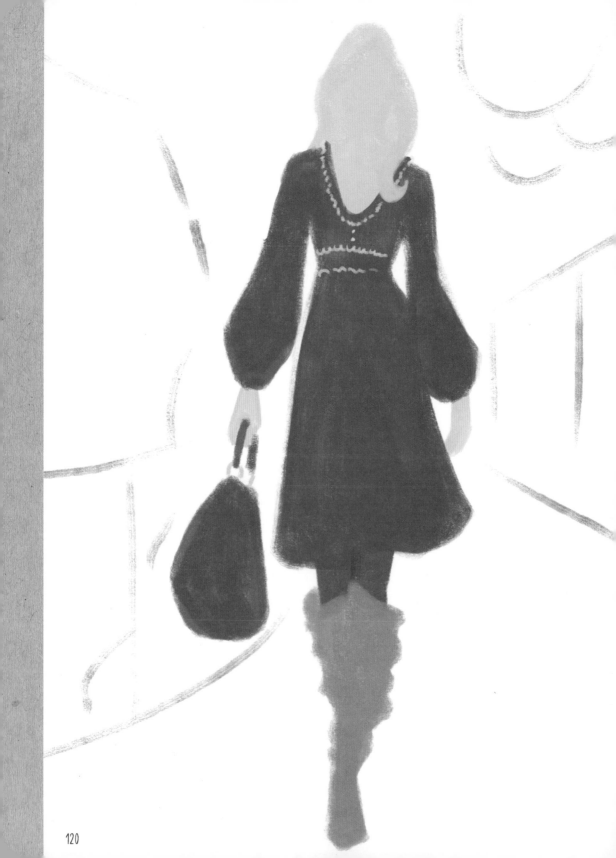

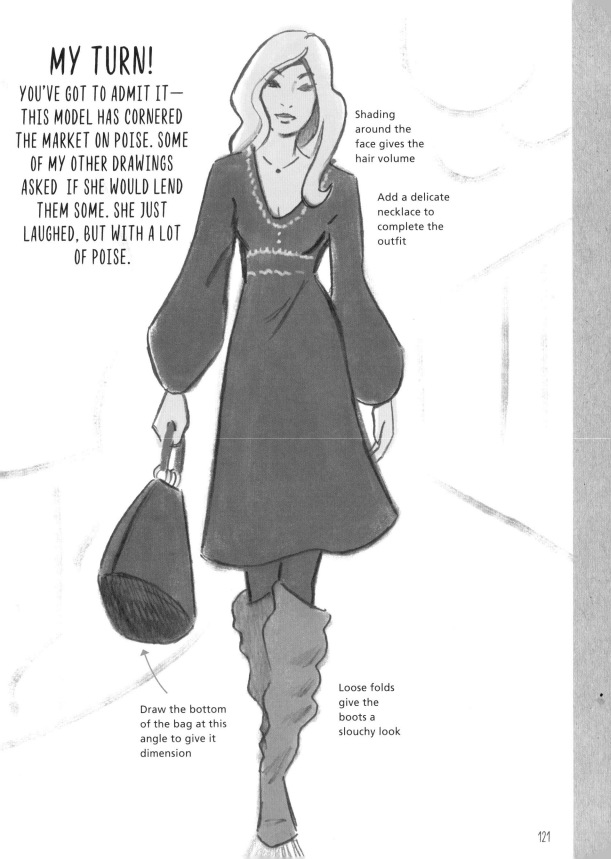

MY TURN!

YOU'VE GOT TO ADMIT IT—THIS MODEL HAS CORNERED THE MARKET ON POISE. SOME OF MY OTHER DRAWINGS ASKED IF SHE WOULD LEND THEM SOME. SHE JUST LAUGHED, BUT WITH A LOT OF POISE.

Shading around the face gives the hair volume

Add a delicate necklace to complete the outfit

Draw the bottom of the bag at this angle to give it dimension

Loose folds give the boots a slouchy look

121

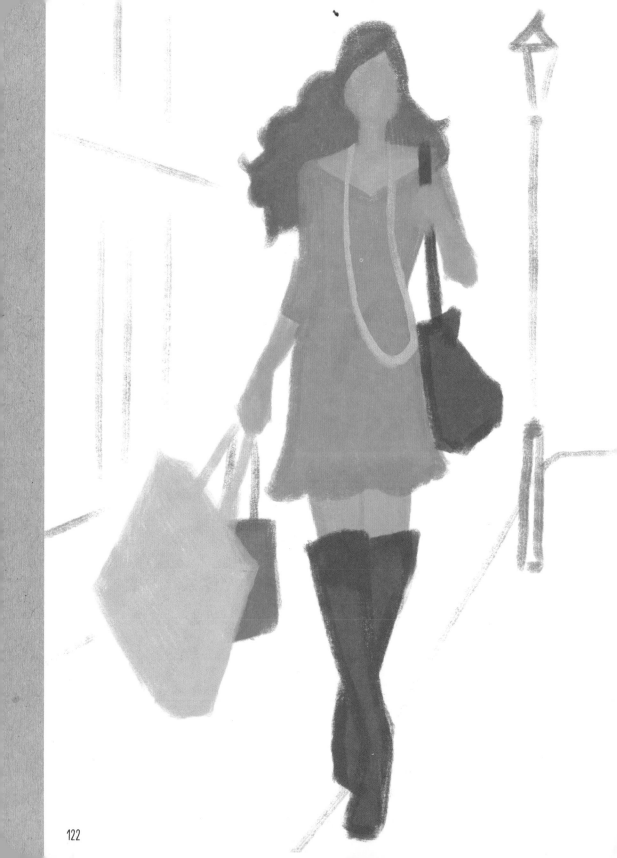

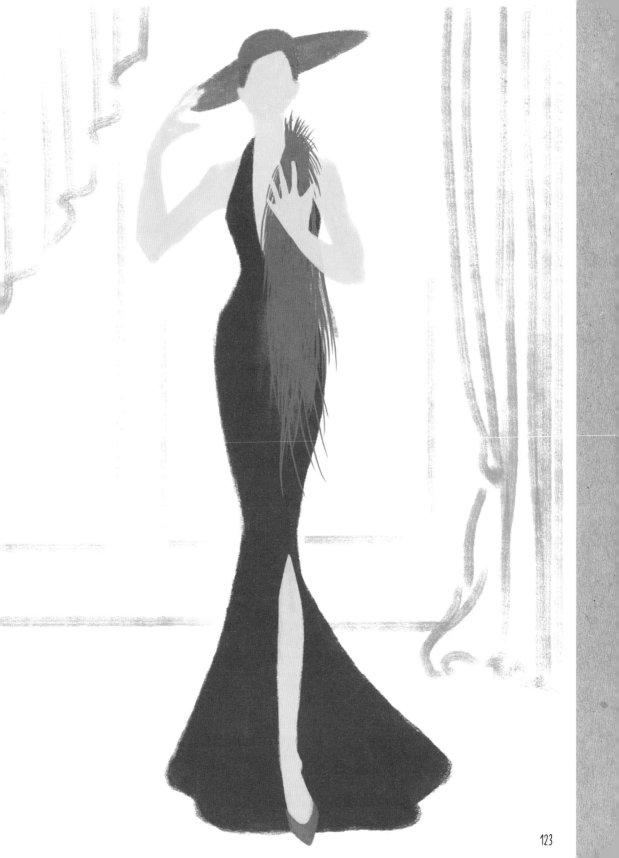

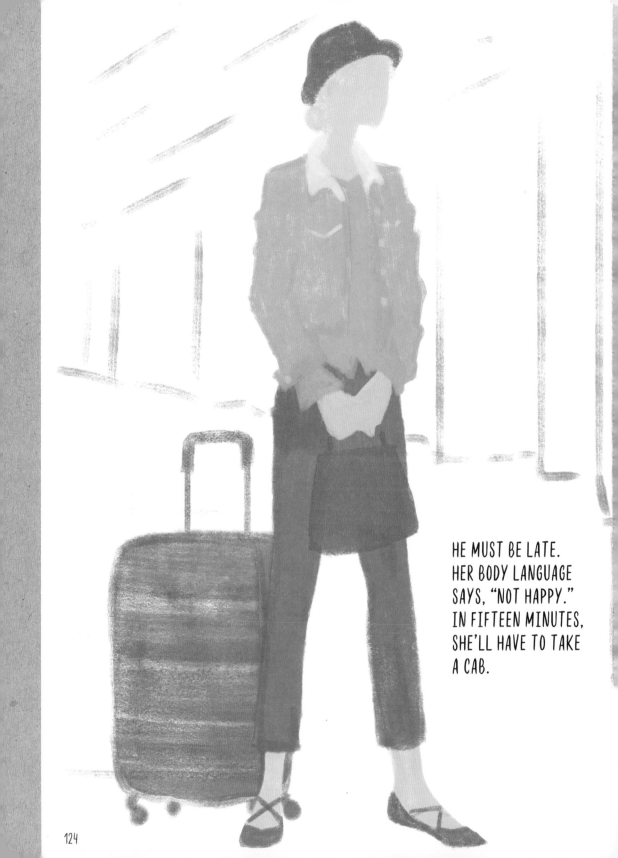

HE MUST BE LATE.
HER BODY LANGUAGE
SAYS, "NOT HAPPY."
IN FIFTEEN MINUTES,
SHE'LL HAVE TO TAKE
A CAB.

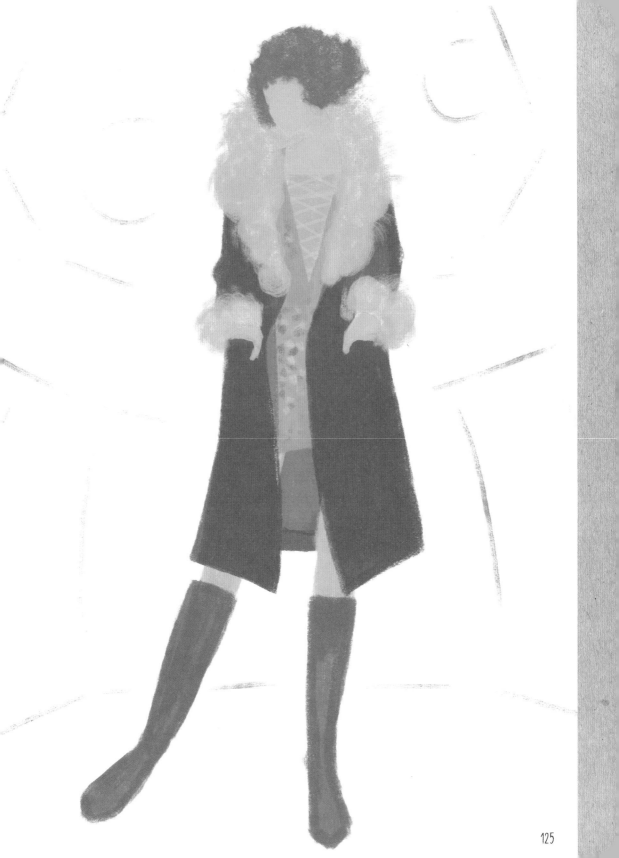

LOOKS LIKE A DRESS IN NEED
OF A PATTERN. ANY IDEAS?

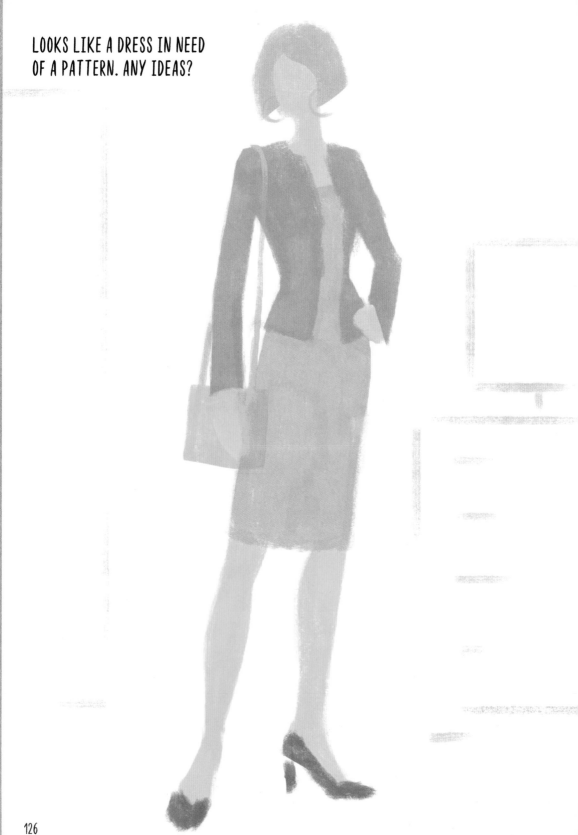

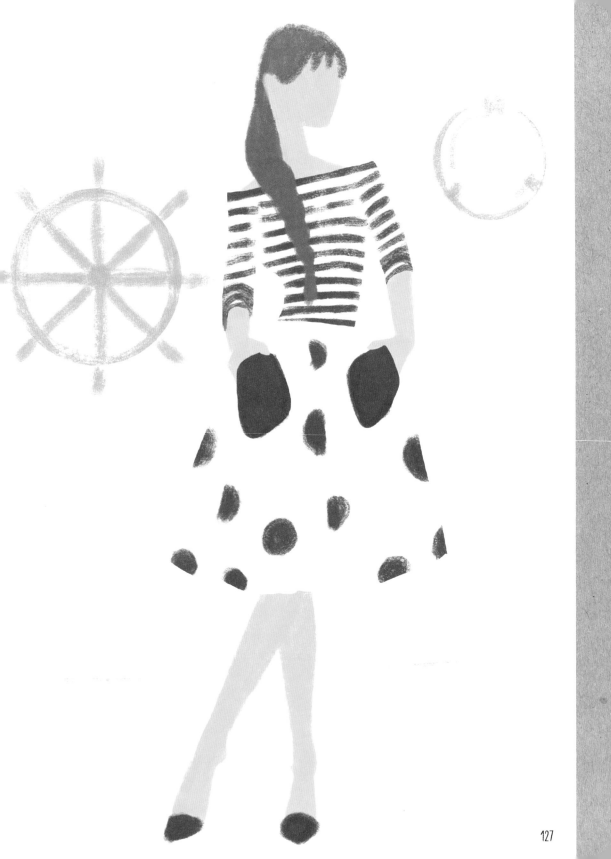

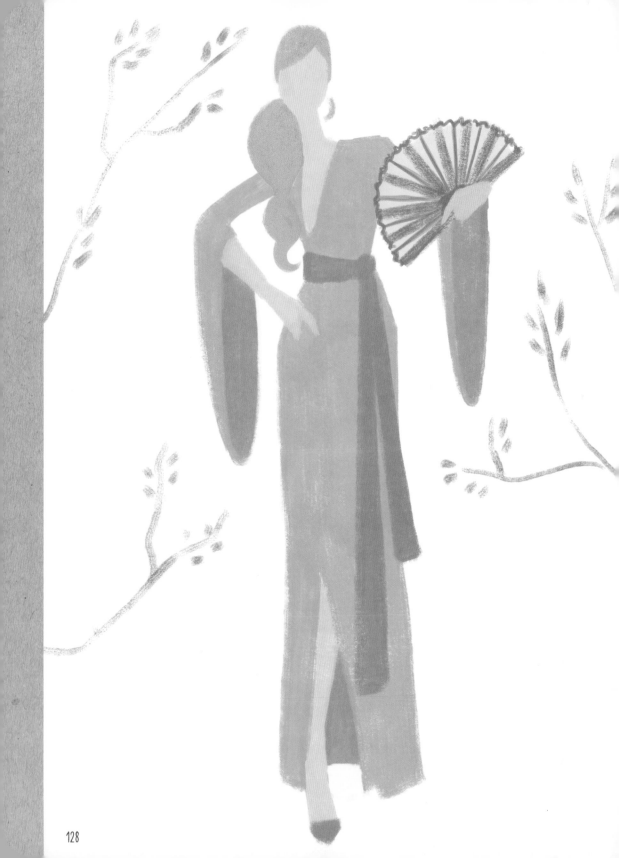

LONG, DRAPED ITEMS, SUCH AS THIS
FULL-LENGTH SHAWL, ARE DRAWN
WITH STRAIGHT LINES ON ONE SIDE,
AND WAVY LINES ON THE OTHER.

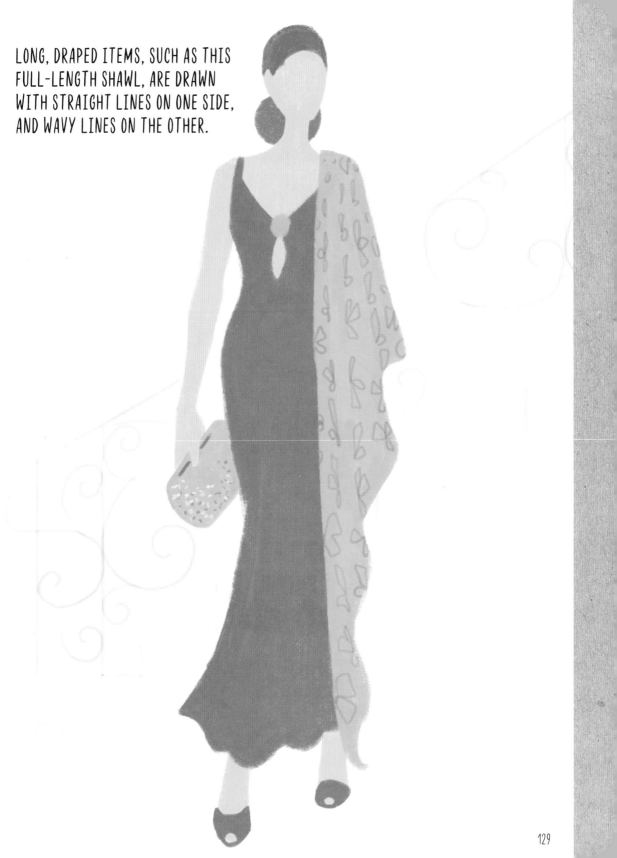

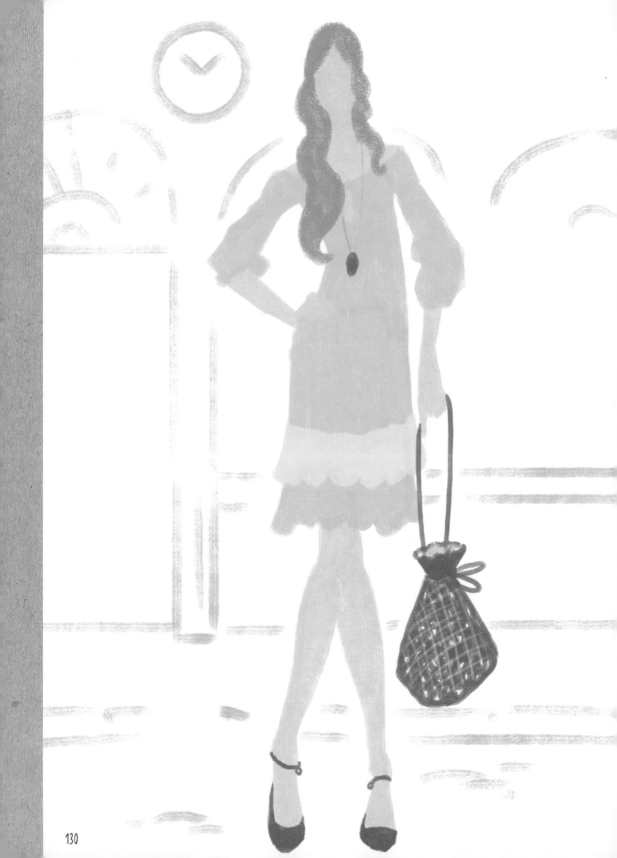

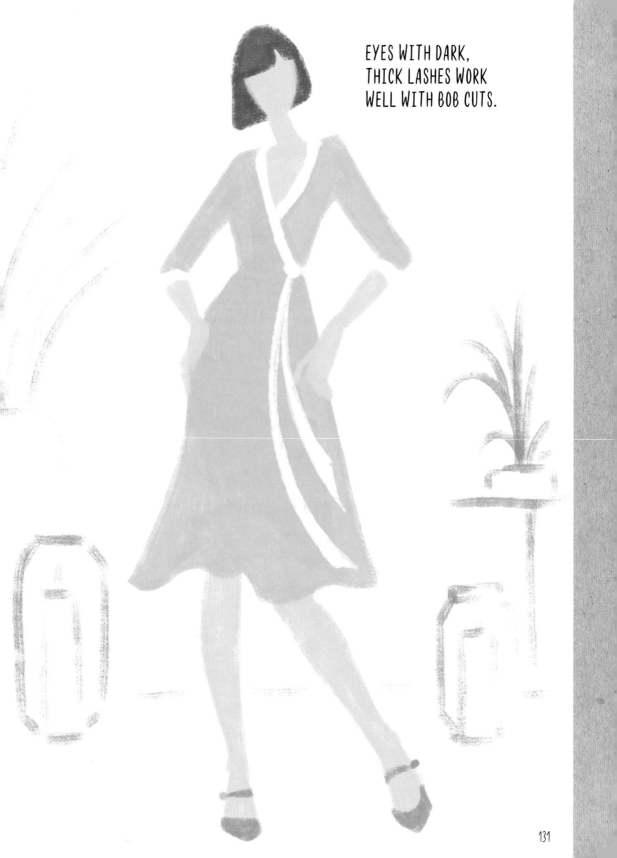

EYES WITH DARK,
THICK LASHES WORK
WELL WITH BOB CUTS.

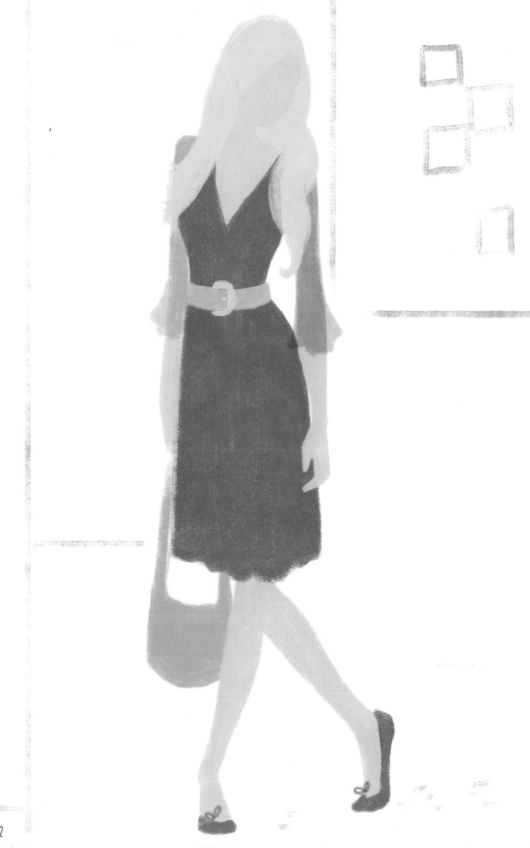

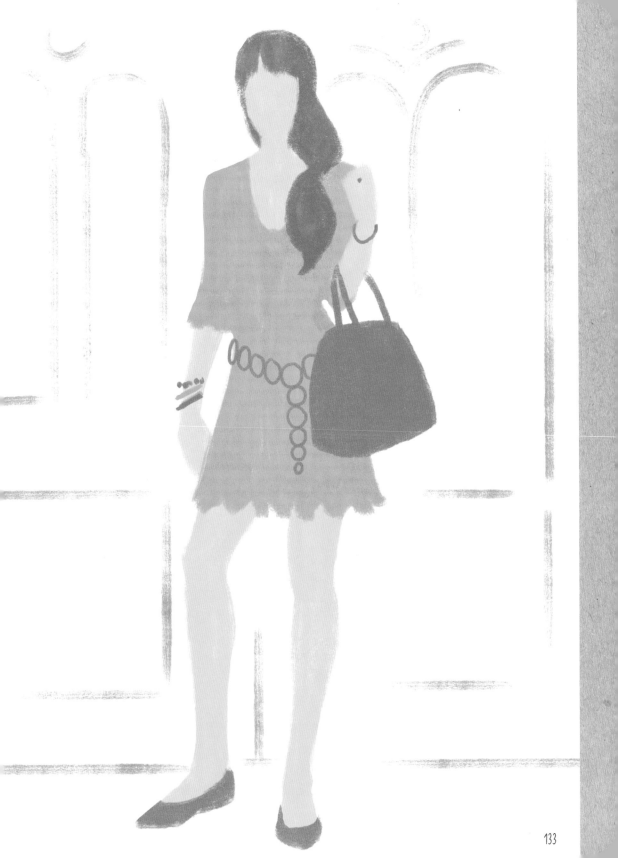

THIS FUN POSE IS
MATCHED BY THE
LIVELY OUTFIT. TRY
A SKETCHY LINE TO
CONVEY A CHEERFUL
ENERGY.

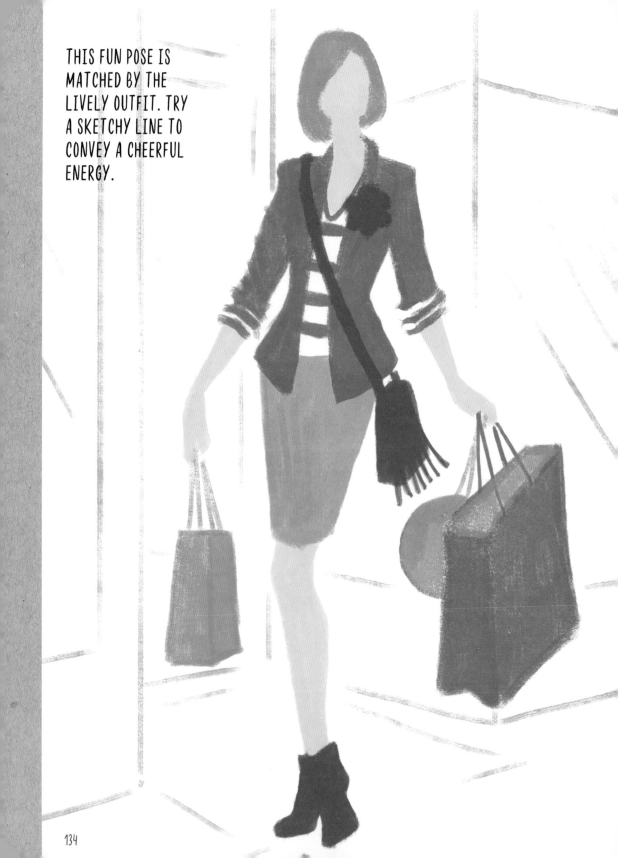

COMPLETE THE
SOPHISTICATED LOOK
BY DRAWING WITH
DELICATE LINES.

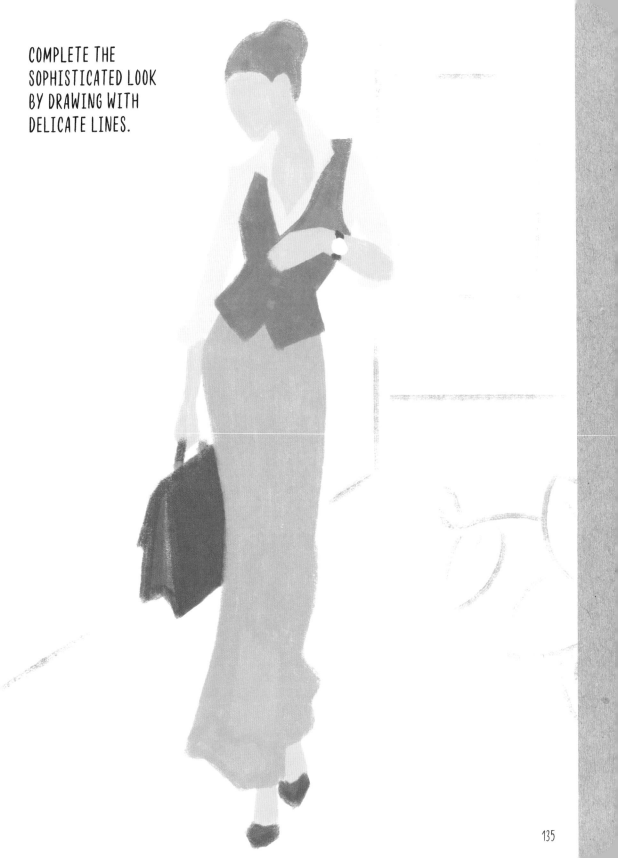

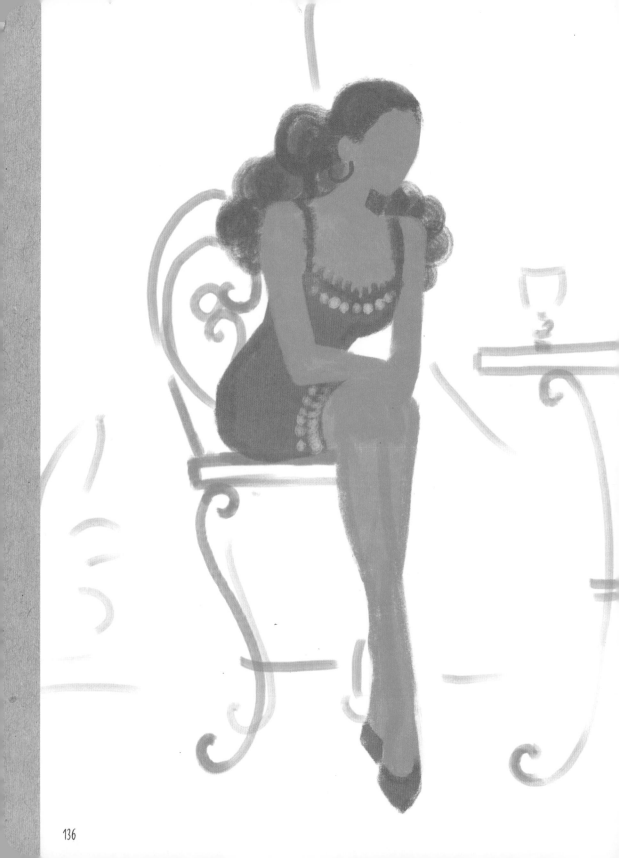

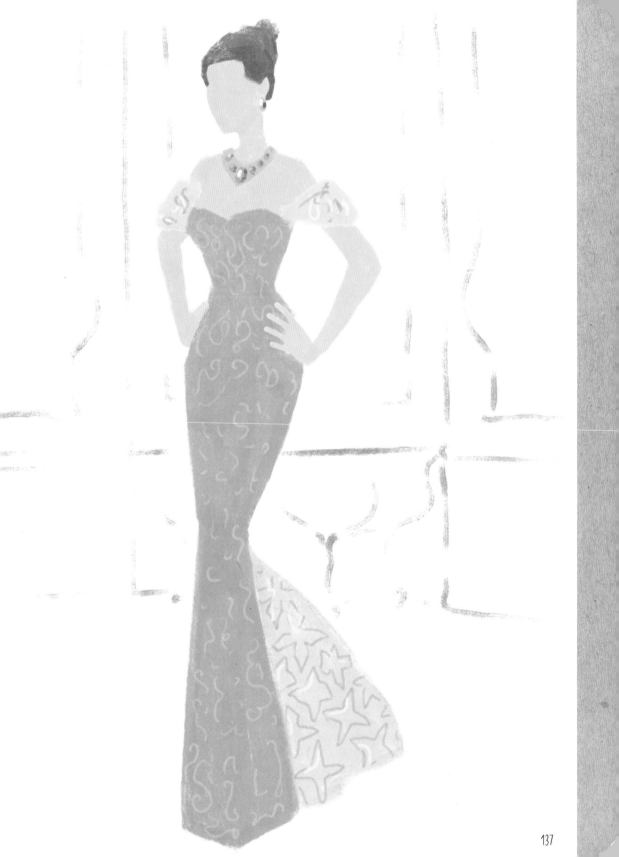

A BELT, PURSE, NECKLACE, AND BRACELET ARE A FEW OF THE ITEMS YOU COULD USE TO FLESH OUT THIS FIGURE.

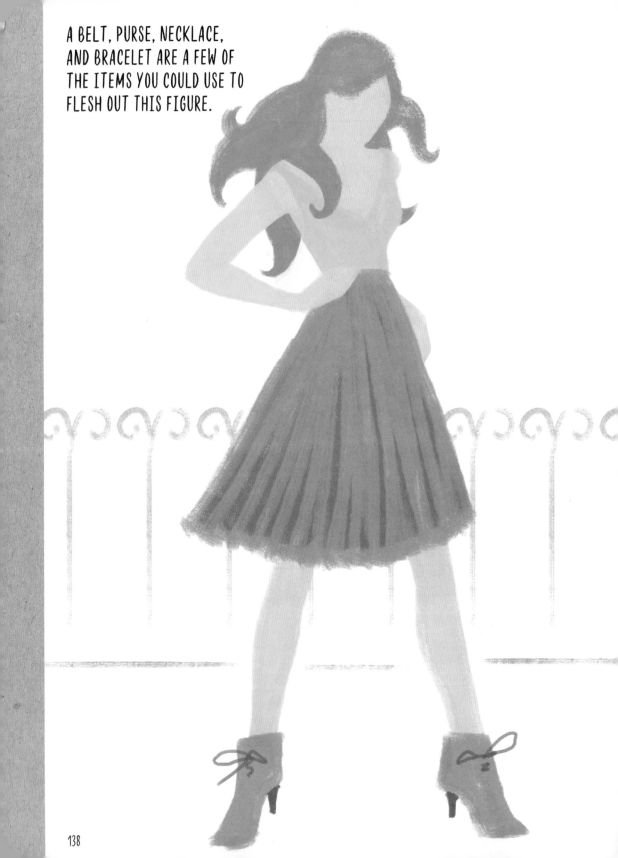

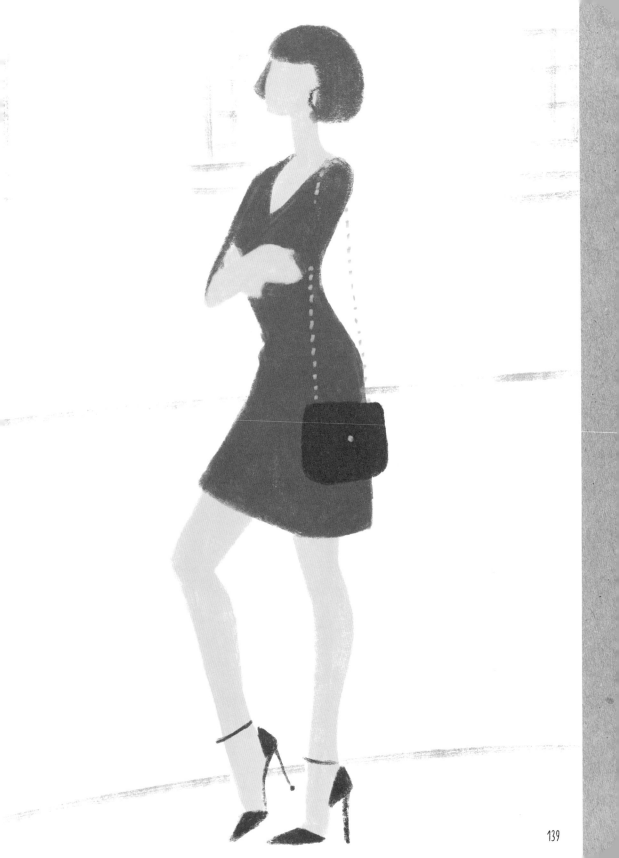

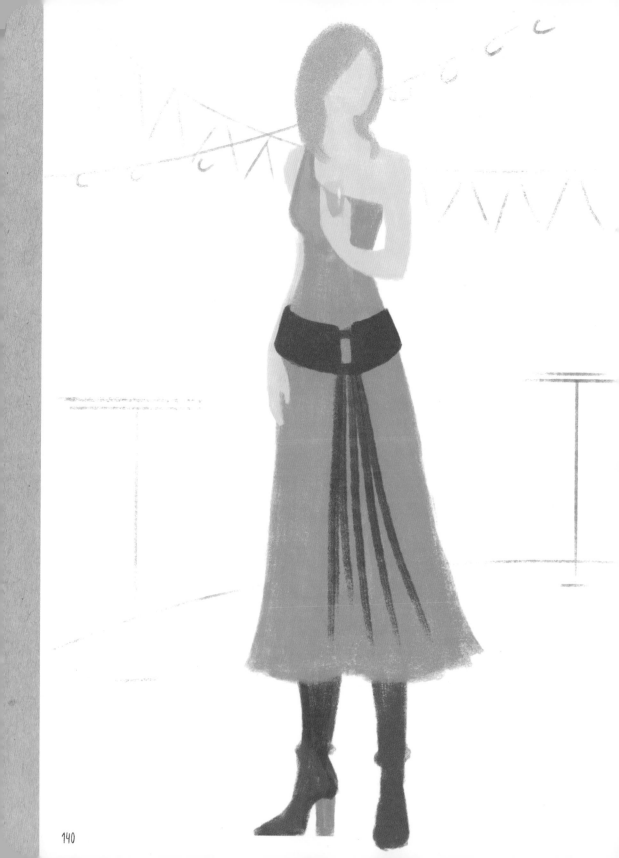

WHEN THE HAIR IS LIGHT,
IT HELPS TO OUTLINE THE
FACE WITH A SLIGHTLY
DARKER LINE.

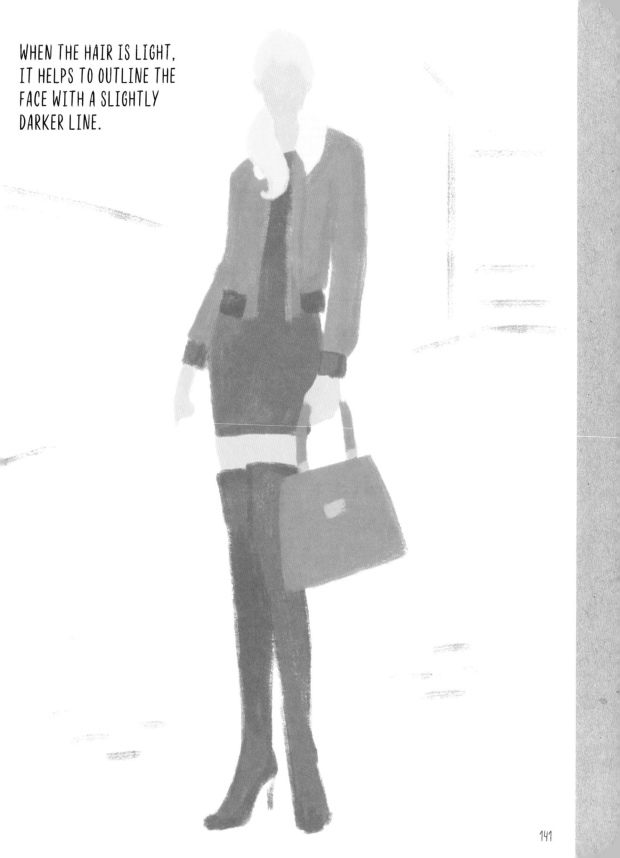

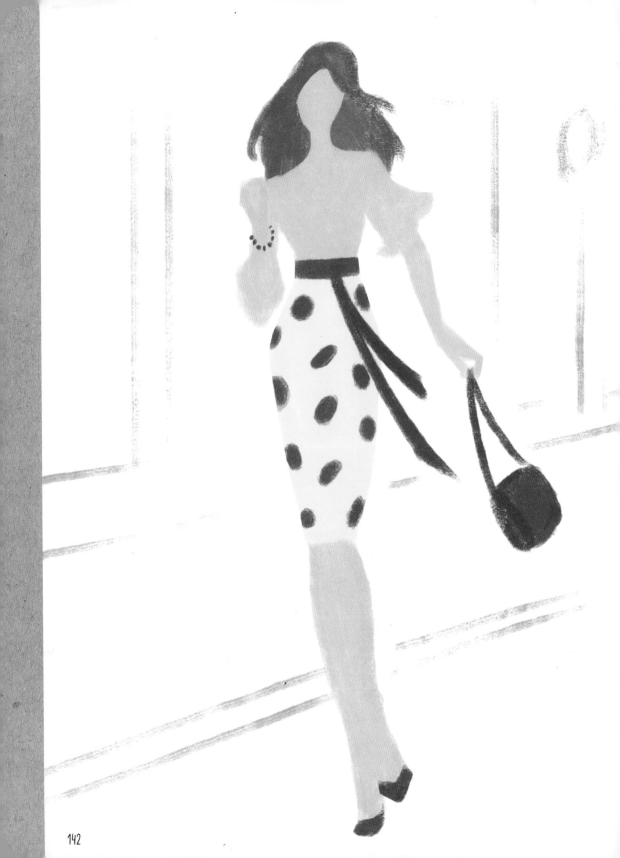

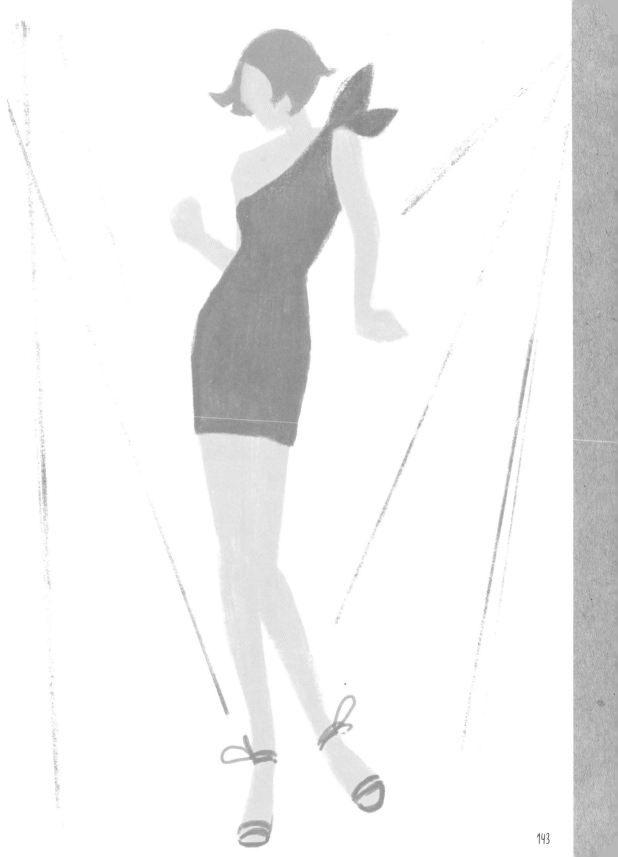